POSTCARD HISTORY SERIES

Cranberry Lake
and Wanakena

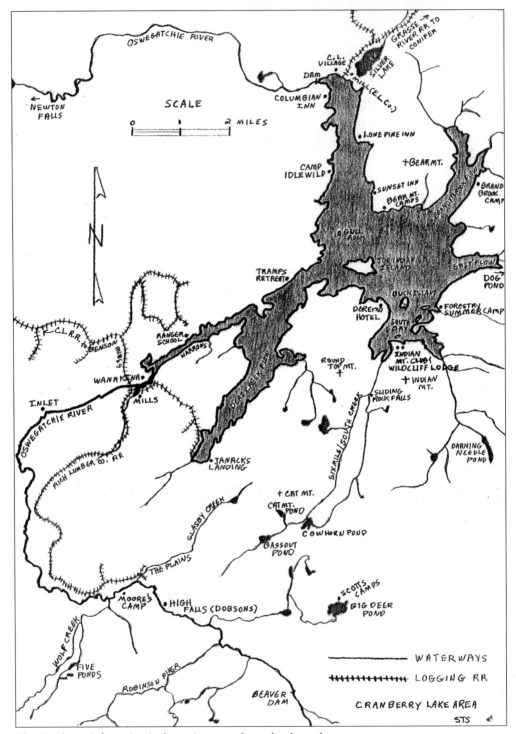

The Cranberry Lake region is shown in a map drawn by the author.

POSTCARD HISTORY SERIES

Cranberry Lake
and Wanakena

Susan Thomas Smeby

ARCADIA

First printed in 2002.

Published by Arcadia Publishing,
an imprint of Tempus Publishing, Inc.
2A Cumberland Street
Charleston, SC 29401

Printed in Great Britain.

Library of Congress Catalog Card Number: 2001096575

For all general information contact Arcadia Publishing at:
Telephone 843-853-2070
Fax 843-853-0044
E-Mail sales@arcadiapublishing.com

For customer service and orders:
Toll-Free 1-888-313-2665

Visit us on the internet at http://www.arcadiapublishing.com

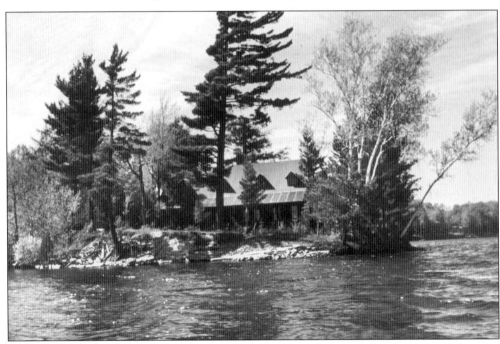

In 1896, this stockade log cabin was built on the west shore of Cranberry Lake by Dr. W.W. Boyd of St. Louis, Missouri. The 130-acre property was purchased in 1904 by Frank Wilder of Carthage and was named Camp Idlewild. The camp hosted the owner's many friends and employed the area's best-known guides until the 1950s, when it was sold and the shoreline acreage was subdivided. In 1984, the Idlewild burned and was replaced by a new log home on Lightning Point.

CONTENTS

Introduction 6

1. The State Dam and Cranberry Village 7

2. Hotels, Clubs, and Boating up the Lake 23

3. Cranberry Lake Lumbering 43

4. Highlights of the Cranberry Lake Region 53

5. The Village of Wanakena 65

6. Milling and Logging at Wanakena 91

7. Wanakena to Inlet and High Falls 103

8. The Ranger School and Forestry Summer Camp 115

INTRODUCTION

In April 1865, the New York State legislature authorized the building of a dam at the foot of Cranberry Lake—a widening of the East Branch of the Oswegatchie River as it flows north to the St. Lawrence. The original lake, named for its many cranberry bogs, had a pear shape and a surface area of about five square miles. The first dam, 13 feet in height and 80 wide, doubled the lake surface, backed water up the creek valleys for several miles, and increased the shoreline to about 160 miles. No attempt was made to clear the land before flooding, and for many years, the shores were ringed with dead and decaying trees and stumps (some of which are still visible). Cranberry Lake is now the third largest in the Adirondack Park, after Lake George and the Sacandaga Reservoir.

Until the 1860s, Cranberry Lake was known only to a few trappers, sportsmen, and surveyors. No roads reached the lake from any direction. The closest was an old military road, the 1812 Albany Road, which crossed the Oswegatchie River two miles above Wanakena at Inlet. This was little more than a hunters' trail. The earliest settlers at Cranberry came one or two generations later than those in other parts of the Adirondacks. Lumbering operations were equally slow to begin harvesting the rich virgin timber of the region. The first direct access to Cranberry Lake came in 1864 (three years before the dam's completion), when a road was cut north from the foot of the lake, leading to Canton, the county seat. This was a rough, two-day stagecoach ride, but it linked Cranberry Lake to the populated villages in northern St. Lawrence County. The real opening of the Cranberry region began with the Rich Lumber Company's move to Wanakena in 1902. A railroad connection was built to the Carthage & Adirondack Railway's depot in Benson Mines, six miles to the west. Suddenly, it became possible for tourists and summer residents to leave the cities and (within a few effortless hours) to be at their destination—either in Wanakena or by boat from there to any point on Cranberry Lake. In 1913, the Emporium Lumber Company extended the Grasse River Railroad 16 miles west from its mill in Conifer, giving Cranberry Lake an eastern connection to the New York Central Railroad.

Both the explosion of tourism and the major lumbering operations at Cranberry Lake and Wanakena coincided with the heyday of the postcard's popularity, from 1905 to 1935. Most of the postcards in the book date from this period. Of the commercial buildings depicted in the cards—hotels, stores, depots, and mills—almost all are gone, although many private homes and camps remain. The Rich Lumber Company, the Emporium Lumber Company, and other large landholders eventually sold most of their Cranberry Lake properties to the state, an ongoing process from 1912 to the 1940s. About 75 percent of the shoreline of Cranberry Lake is now owned by the state. South of Wanakena is the 95,000-acre Five Ponds Wilderness Area, one of the largest (and wildest) in the Adirondack Park. Tourism and recreational activities in the Cranberry Lake region have the same appeal today as they did 100 years ago to those nature lovers and sportsmen attracted to one of the least-developed areas of New York State.

One
THE STATE DAM AND CRANBERRY VILLAGE

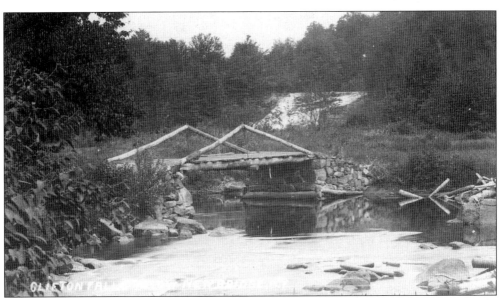

In 1864, a road was cut 18 miles south from the village of Monterey (now Degrasse) to Cranberry Lake, generally following the south branch of the Grasse River. This allowed travelers from northern St. Lawrence County to make a jolting, dusty two-day stagecoach trip to Cranberry Lake—justified by the fame of the lake as a hunting and fishing paradise. Beginning at Canton, the first overnight stop was several miles south of Monterey at Clifton Falls, pictured in this 1914-postmarked card. Nearby were Clarksboro and the Clifton Iron Mines. The second day's journey took the stage to the foot of Cranberry Lake, just below the dam. Now called the Tooley Pond Road, it is still a popular local backwoods drive.

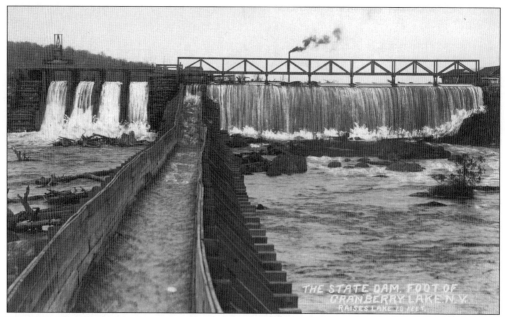

The state dam was built in 1865–1867 at the outlet of Cranberry Lake. The first log dam was a 13-foot-high timber crib structure filled with stone. The spillway was 80 feet wide. The sides of the four sluiceways had vertical grooves into which stop logs were placed. The raising or lowering of the stop logs was a crude method of controlling the discharge of water from the reservoir. By the time of these *c.* 1910 cards, the dam had been enlarged and raised to a height of 18 feet. Also, a log flume had been added to float pulpwood down the Oswegatchie River. The lower card shows a group of spring trout fisherman posing on top of the dam, displaying fly-casting rods, creels, and nets.

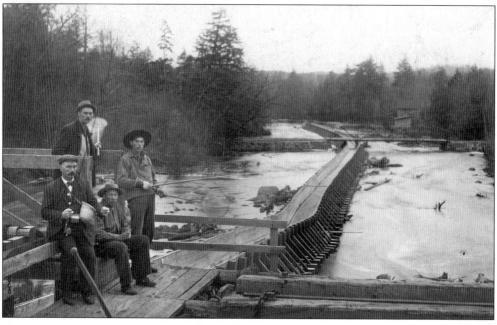

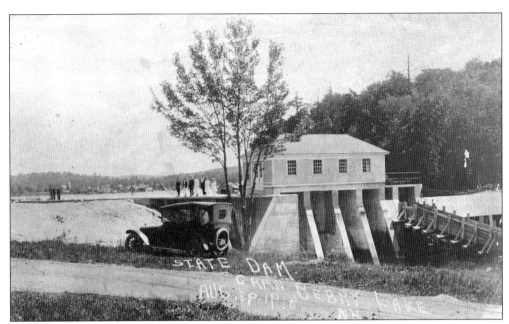

By 1915, the old log dam was rotten and leaking badly. It was also difficult to determine how much water should be drawn to supply downstream industries. In 1916, a new concrete dam was built behind the old one. This view of the new state dam is dated August 19, 1918, and may show the car's occupants on a Sunday outing. Cranberry village is in the background. Since 1916, the dam has been rebuilt twice but still looks very much the same.

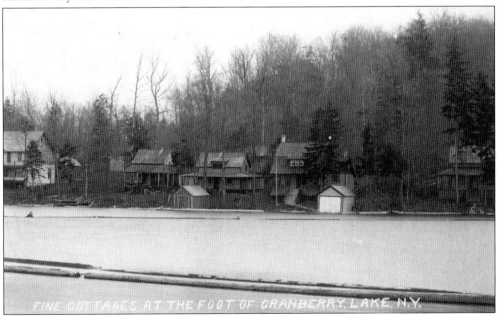

The first settlement at Cranberry began around the dam. This *c.* 1910 view of the west shore, just south of the dam, may show summer cottages or the homes of guides. Guides were the earliest settlers, attracted by the demand for their services from tourists and sportsmen. The cottage and boathouse second from the right are the only buildings still standing. The home site to the north is now part of the New York State boat launch. To the south, newer cottages line the shore.

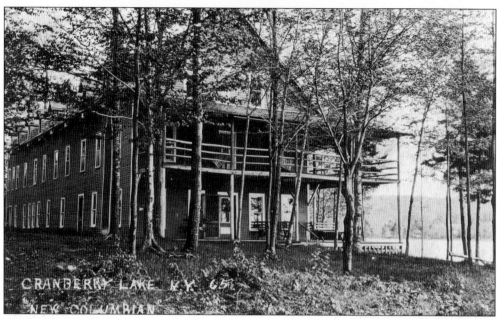

The New Columbian Park Hotel was built by Charles Dewey in 1897 on the west shore, about a half mile above the dam. It was a long, three-story structure accommodating 100 guests and maintained a large vegetable garden and its own dairy herd. At the time of this 1907-postmarked card, the hotel was open from May 1 to November 1, with rates of $2 per day and $12 to $16 per week.

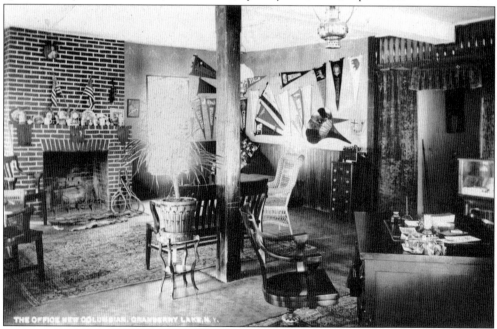

In this 1914-postmarked card, the office at the Columbian Hotel seems to avoid a rustic look. The ceilings and walls are plastered, and oriental carpets cover linoleum floors. The inn's sports and activities were important attractions, including a bowling alley, poolroom, amusement hall, two tennis courts, and, of course, water sports. The décor seems to reflect this; trophies line the fireplace mantle, and college team pennants are hung on the walls.

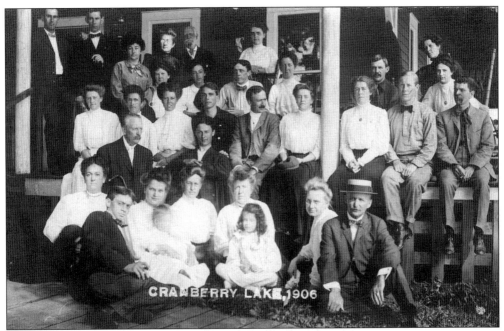

For many years, the Columbian Hotel was the center of summer social life at the northern end of the lake. There is no message on this 1906-dated card. The people on the porch could have been an assembly of guests, staff, or both. Eventually, tourism declined, and the Columbian became more of a rugged lumberjack's hotel. After a succession of owners, it was demolished in 1935, and the site is now occupied by private camps.

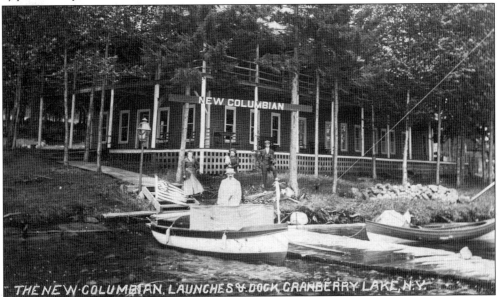

The Columbian's motorboat *Margarete* is seen to the left in this 1913-postmarked view of the hotel's launches and dock. At this time, the hotel was reached by water from Cranberry village. Soon, an access road (now called the Columbian Road) was cut south from the dam. The rather alarming message reads, "This is where they took us during the smallpox. Swell place believe me." The writer at least seems to be enjoying her quarantine.

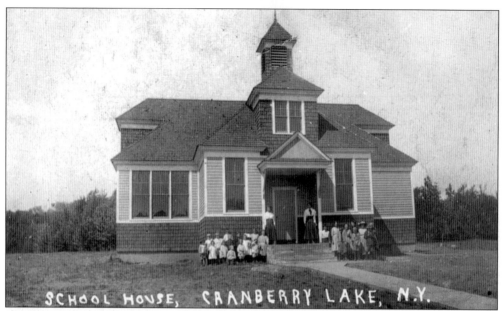

SCHOOL HOUSE, CRANBERRY LAKE, N.Y.

The first school at Cranberry was built from logs in the 1880s and was located just above the dam on Riverside Drive, a continuation of the Tooley Pond Road as it entered the western village. It burned before 1910. The conservation department garages now occupy the site. A larger schoolhouse, seen here, was built in 1911 east of the first school's site. After the second school burned in 1918, classes were continued in the town hall.

PHONE 11-F-23. RUBYOR'S HOTEL. ARTHUR RUBYOR, PROP. THE PLACE TO GET A GOOD NIGHTS REST AFTER A HARD DAYS DRIVE. OLD FASHIIONED HOME COOKING. GOOD FISHING AND HUNTING. OPEN YEAR ROUND CRANBERRY LAKE. N. Y. OFFICIALLY INSPECTED AND APPROVED BY PUBLICITY TRAVEL BUREAU

Rubyor's Hotel, located just below the dam on Riverside Drive, is pictured here in the 1930s. It was built in 1900 as the private home of Jay Hand, Cranberry Lake's game warden. In 1913, it was sold to Mike Brainard, who operated it as Brainard's Inn until his death in 1926. Arthur Rubyor then ran the hotel until 1939, when it was sold again and renamed the Northwood Inn. It burned in 1942.

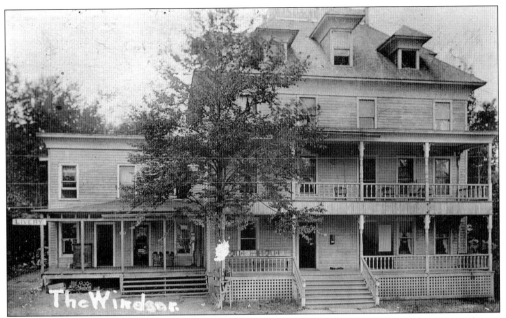

The Windsor Hotel was built in 1905 near the western edge of Cranberry village, for local lumberman George Bushey. He soon sold the hotel to the Bissell Brothers, who were running a sawmill on the point across the road. The message on this 1914-postmarked card states, "Gaining about a pound a day through the heavy meals; we have everything imaginable on our menus except cinnamon buns." The Windsor burned in 1931.

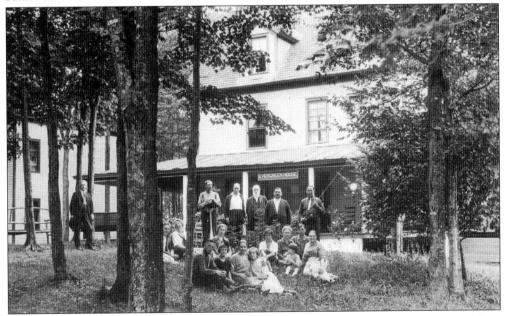

The Evergreen Hotel was built in 1896, just east of the later Windsor Hotel, by pioneer guide Richard Bullock. William "Mack" McAleese Sr. bought the hotel in 1918. Mack sold it to his son William McAleese Jr. in the 1930s but continued to guide fisherman and tell tall tales until his death in 1946. In this card (dated July 4, 1923), William McAleese Sr. can be seen standing with a canoe paddle to the left in the center group.

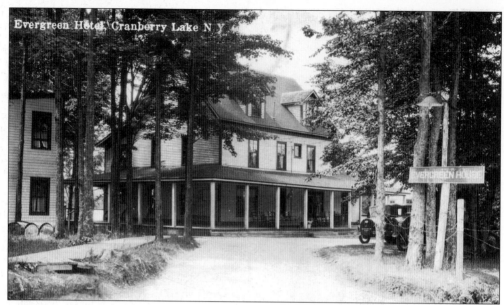

Evergreen Hotel, Cranberry Lake N Y

Besides yarn spinning, guiding, and serving as town justice, William McAleese Sr. was well known for calling at square dances. The message on this card, postmarked August 1937, seems to confirm this: "It's grand here—we even have swell square dances Saturday nights. Oh Boy these mountaineers." The Evergreen Hotel was razed in 1968 and was replaced by a new hotel, now converted into apartments.

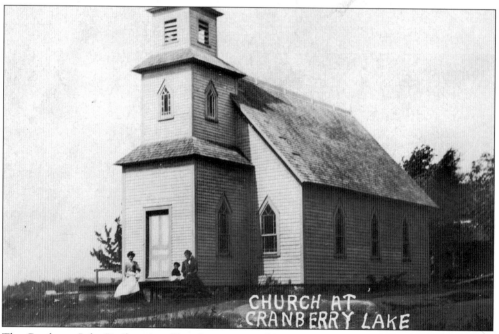

CHURCH AT CRANBERRY LAKE

The Cranberry Lake Presbyterian Church, constructed in 1897 on the Main Street lakefront, served summer tourists and the few permanent winter residents. Known as the Little White Church, it is still in use.

This *c.* 1910 view looks east down Main Street from the center of the village. The first building on the left, the Catholic church, was sold in 1935 and converted to private housing. Next is the town hall and post office, demolished in 1976. The boardinghouse third in line is still standing, though remodeled. The fourth building, a hardware store, was gone by 1920. The large Cranberry Lake Inn can be seen at the end of the street.

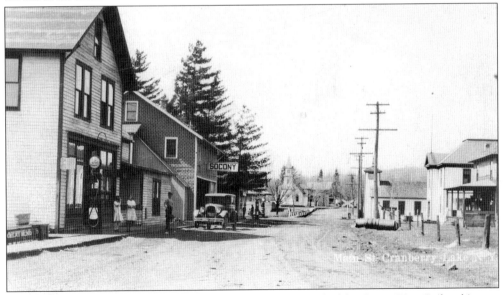

In this 1920s card of Main Street, looking west, the crossing guard of the Grasse River Railroad is now visible in front of the Catholic church. The store to the left was built *c.* 1905 by the Bancroft Brothers. It was sold in 1921 to Givens & Marsh, who enlarged it and installed the Socony gas pumps. It burned in 1942. The Presbyterian church can be glimpsed across the end of the lake.

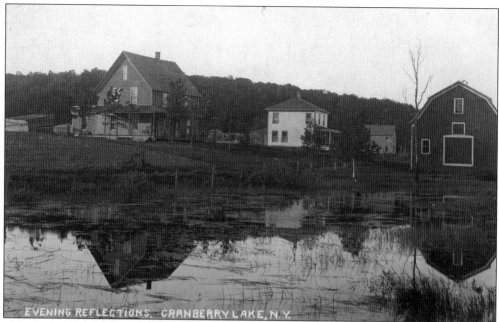

EVENING REFLECTIONS, CRANBERRY LAKE, N.Y.

This 1911-postmarked view looks north from Main Street, just west of the Catholic church. The white house at the center was owned by one of the Bissell Brothers, builders of the Bissell sawmill in 1904. The barn to the right was also built by the company. These still stand on Mill Street, but the house to the left is gone, as are the "evening reflections." This low-lying area was filled in when modern state Route 3 was constructed in 1926.

Post Office, Cranberry Lake, N. Y.

Although unmailed, this card of the Clifton town hall, post office, and barbershop can be dated—the Emporium Lumber Company sawmill to the north operated from 1917 to 1927. The tracks at the Main Street railroad crossing ran between the town hall and the Catholic church. The town hall served briefly as a school from 1918 to 1921, until a new schoolhouse was built across the road from the Presbyterian church. This building is now the Clifton community center, library, and post office.

16

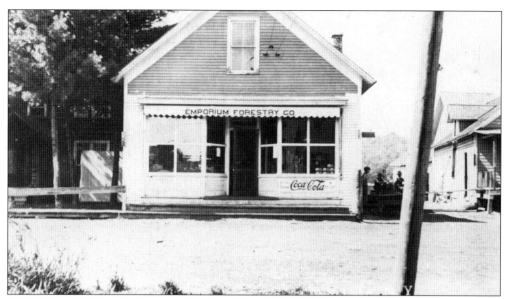

The Emporium Lumber Company general store, pictured in this *c.* 1920 card, was located on the lake shore across from the town hall. It was originally a boardinghouse and then a store owned by the Bissell Brothers. According to a 1922 advertising brochure, the Emporium store offered "fresh fruits, vegetables, meats, eggs, milk, ice cream, paints, fishing tackle, hardware, motor oils, gasoline, drugs and notions." An even larger general store and office was located at the company's headquarters in Conifer, 16 miles to the east.

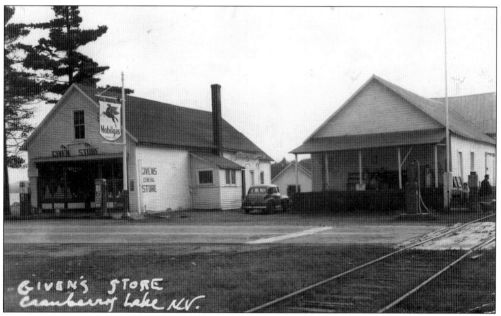

The former Emporium Lumber Company store, to the left, continued to operate under a series of owners. The large shed to the right was the western terminal of the Grasse River Railroad, next to the dock on Cranberry Lake. This card is dated 1947, the year before the tracks were taken up from Cranberry nearly to Conifer. Both buildings still stand. The old store now houses the Reynolds art studio, and the shed is Emporium Marine, supplying rental boats, camping supplies, and sporting goods.

17

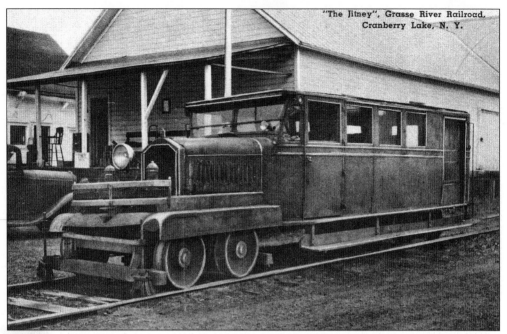

To economize moving passengers and mail between Cranberry and Conifer, the Emporium Lumber Company used self-propelled gas speeders. Pictured is the "Jitney," or "Jumping Goose." It had a bus engine and body, mounted on rail wheels that were chain driven. The speeder met the New York Central sleeper car near Conifer. It turned around outside of Cranberry village and backed into the end of the line, ready for the return trip. It continued to operate into the 1940s.

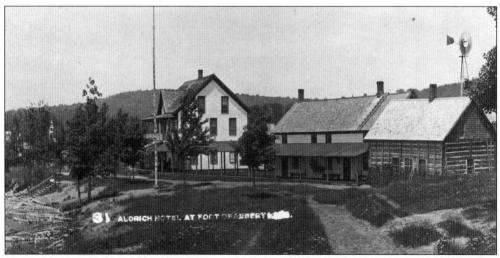

Thomas's Log Hotel was built in 1875 by Richard Thomas at the east end of the village. The original log hotel is seen to the right in this 1905 card. In 1883, the hotel was purchased and enlarged by Riley Bishop and his wife, "Auntie B." It became famous as a sportsmen's retreat. Artist Frederic Remington began his yearly visits to the lake (1889–1899) with a stop at the inn, sketching guides on the porch and dining on "mountain lamb."

C.L. INN AND PINES.
CRANBERRY LAKE N.Y.

In 1899, Ed Aldrich bought Bishop's Hotel and operated it as the Cranberry Lake Inn. Aldrich sided and painted the old log section—now the bar, with guide's quarters overhead, reached by a ladder. The dining room and kitchen ell were adjacent. In this 1908-postmarked card, the steamer *Helen* is at the inn's dock. The spire of the Presbyterian church can be seen in the center of the village. To the far left is the Bissell sawmill.

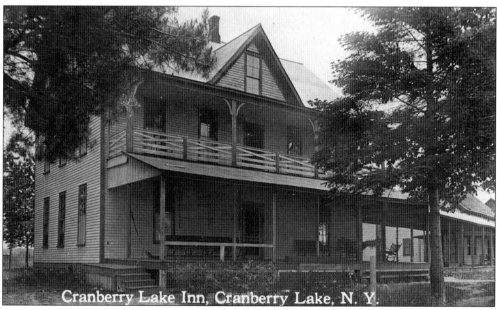

Cranberry Lake Inn, Cranberry Lake, N. Y.

In 1910, Ed Aldrich sold the Cranberry Lake Inn to the Emporium Lumber Company. The company successfully promoted the appeal of its inn via advertising brochures: "surrounded by immense tracts of virgin forests . . . woods full of deer . . . wild flowers in abundance . . . good beds and excellent cuisine. . . . Bath rooms have just been added." This *c.* 1915 view from the lakefront is of the main boardinghouse.

LOOKING UP THE LAKE FROM THE LAWN. CRANBERRY LAKE, N.Y.

This 1910-postmarked card shows the view from the Cranberry Lake Inn, looking south across the lake to Indian and Cat Mountains. The Emporium Lumber Company operated the inn until it burned in 1926, killing a lumberjack. Subsequent owners continued the process of rebuilding, and Cranberry Lake Lodge now occupies the site.

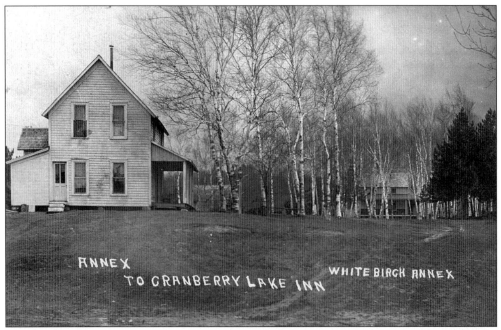

ANNEX TO CRANBERRY LAKE INN WHITE BIRCH ANNEX

The Cranberry Lake Inn annex was located southeast of the main inn along the shoreline. It was advertised as a "homelike cottage with modern sanitary conveniences" and would have appealed to family groups wishing to stay together rather than board at the inn. The annex eventually burned, and a new cottage was built on its site.

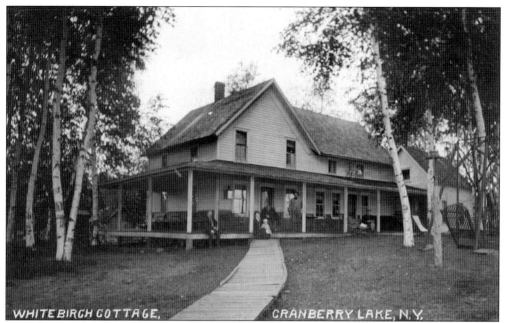

WHITE BIRCH COTTAGE, CRANBERRY LAKE, N.Y.

The large White Birch cottage was built to house the overflow from the Cranberry Lake Inn. It accommodated 25 guests, maintained its own kitchen and dining room, and was separated from the annex by tennis courts and a croquet ground. This card is postmarked 1911, the year after the Emporium Lumber Company bought the cottage along with the inn. After the inn burned, the company continued to operate the Birches until it burned in 1935. A private cottage replaced it.

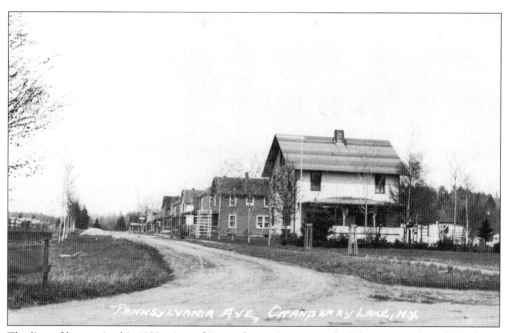

PENNSYLVANIA AVE., CRANBERRY LAKE, N.Y.

The line of houses in this 1920s view of Pennsylvania Avenue marked the eastern edge of Cranberry village. They were built for workers at the Emporium Lumber Company sawmill, constructed in 1917 just north of the village on Silver Lake. Most of these homes are still standing.

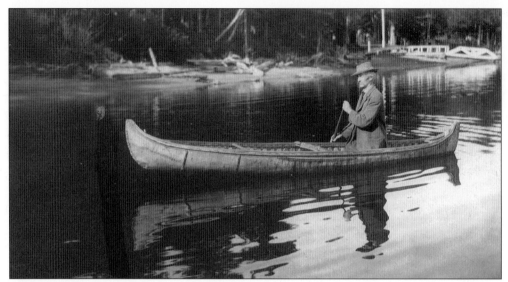

The man paddling a birchbark canoe near the White Birch cottage is believed to be J. Henry Rushton, Canton's world-famous canoe builder. An avid trout fisherman, he made yearly trips to Cranberry and, in 1905, spent his last summer at the lake, hoping to improve his health. His Indian Girl models (low-cost, sturdy, wood-and-canvas canoes) were available for rent at the Cranberry Lake Inn.

This July 29, 1907 view is from a series picturing a family's two-week stay at the Cranberry Lake Inn. Guide Chauncey Wescott was hired for fishing trips and for climbing nearby Bear Mountain. Wescott is seated to the left of the pack basket with his party. He came to the lake as a boy in 1875 to help build Thomas's Log Hotel. Chan Wescott was a popular guide, jack-of-all-trades, and a favorite of Frederic Remington's.

Two
HOTELS, CLUBS, AND BOATING UP THE LAKE

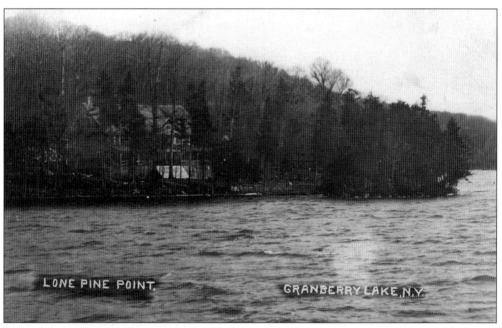

For many years after the dam was built, a tall pine tree stood alone on a point on the east shore of the lake, about a mile south of Cranberry village. The Cranberry Lake Club (soon renamed the Lone Pine Camp) was built here as a private clubhouse *c.* 1906 by a group of sportsmen from Syracuse. These included the club's proprietor, Howard Wolf, and several others. The men also viewed the property as an ideal retreat for their families during the summer. The Lone Pine slowly decayed into the lake and was gone by the time this card was sent in 1916. The message, brief and to the point, reads, "Send me a toothbrush. Explanations later."

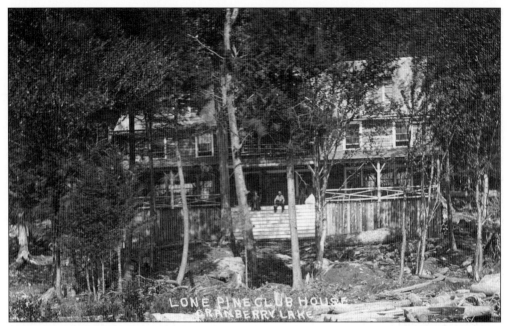

The Lone Pine Camp was purchased by John Howland in the 1920s. He sold it *c.* 1930 to F.A. "Nick" Hovey, who ran it until it burned in 1937. Rental cottages, operated as the Lone Pine Cottage Colony, were built in the 1950s. These are now privately owned. The former Lone Pine Park, extending south from the camp along the lakeshore, was purchased by the state. A large public campground was created in 1935, at the end of the Lone Pine Road.

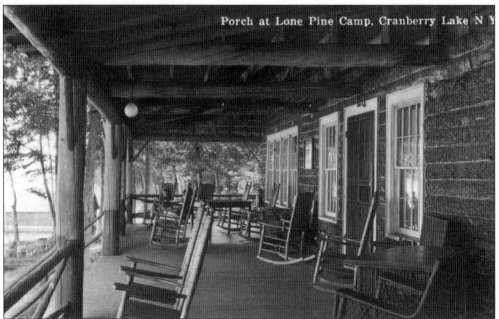

This 1930s card of the Lone Pine shows the porch with its attractive combination of peeled timbers and bark-on logs. The many rocking chairs suggest that tourists were taking Nick Hovey's advertising brochures seriously: "The Inn has the distinction of owning a point from which the best view of boats on the lake may be enjoyed."

24

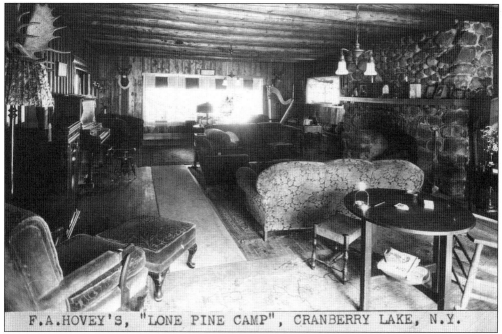

F.A.HOVEY'S, "LONE PINE CAMP", CRANBERRY LAKE, N.Y.

These two cards, both postmarked 1931, show the living room at Hovey's Lone Pine Camp. The décor seems designed to appeal to both tourists and sporting guests. Hunters could admire the moose antlers, deer heads, and other taxidermy mounts. Music lovers could make use of the piano, a six-foot harp, and a record player. Hovey made a special attempt to attract the latter by featuring classical and modern entertainers, bands, and orchestras. All guests would appreciate the comfortable, upholstered furniture, stone fireplace, playing cards, books, and popular magazines.

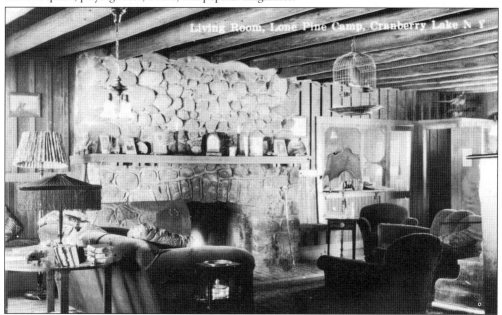

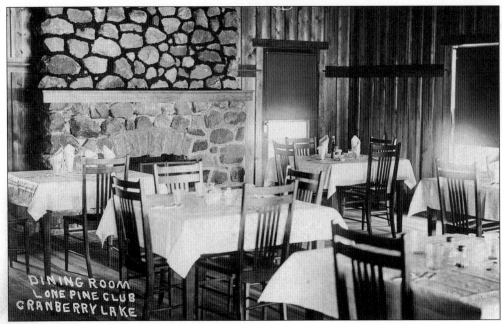

In this 1918-dated view, the Lone Pine dining room features a natural-finish wood floor and board-and-batten walls. The furnishings were simple. Meals were hearty and often. The message notes, "The meals got me, and I never ate so much in my life. Have gained 10 lbs." Similar remarks are made on many vintage cards, and the sender often seems pleased about having put on some much needed weight. Times have changed.

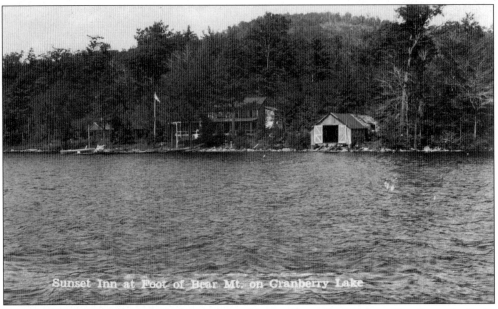

The Sunset Inn was built in 1915 on the east shore, about a mile south of the Lone Pine Camp, by Beebe & Ashton of Rochester. In addition to the main camp, the inn featured two-room sleeping cabins at rates of $17.50 to $24.50 per week. This 1938-postmarked card shows the Sunset Inn shortly before it was demolished. A new cottage was built in its place. It is now in use as a private camp.

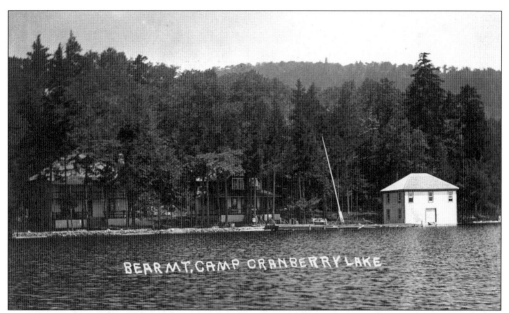

Bear Mountain Camp, at the foot of Bear Mountain, was built in 1905–1906 for John Balderson, a pioneer guide. The original camp, to the right, was followed by the large annex and then the boathouse. The sturdy, two-story boathouse was used for Saturday night dances during the summer, with vacationers from all parts of the lake joining the camp's guests. Trails leading from the camp to the summit of Bear Mountain also attracted many day hikers.

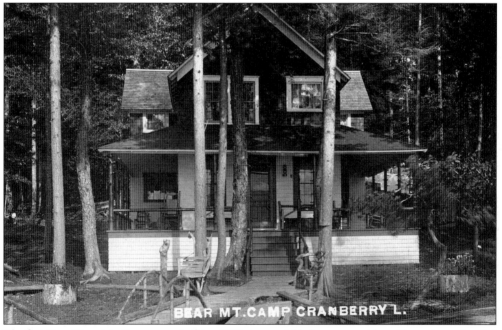

The first Bear Mountain Camp, seen in this c. 1905 view, quickly became popular with sportsmen headed for deer hunting on the mountain or springhole trout fishing at the nearby Brandy Brook Flow. After the annex was built, this camp became the office and dining room. Fresh water for both buildings was piped in from a spring on Bear Mountain. A carbide-gas lighting system served all the rooms via copper tubing.

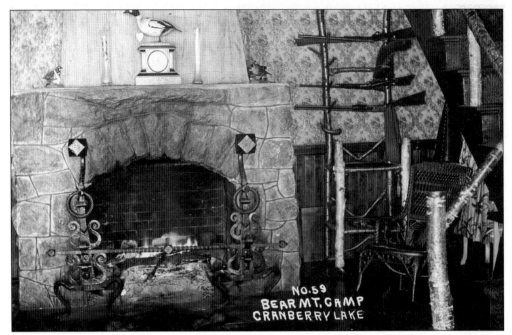

The office at Bear Mountain Camp featured a cut-stone fireplace with a pair of very large and intricate wrought-iron andirons. The camps were known for their fine rustic woodwork. This is evident in the standing gun rack against the wall and in the stairway railings—both fashioned from unpeeled twigs and branches.

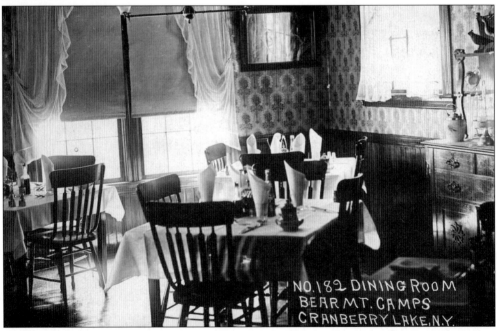

The sender of this July 1908 card was a waitress at the Bear Mountain dining room. She wrote, "Here I am up here, it is a beautiful place for mountain life. This is where I work. Have 3 tables now of 4 each and that is about all I can attend to at once as they all come at the same hour. Last year I was up here at this time. Now write!"

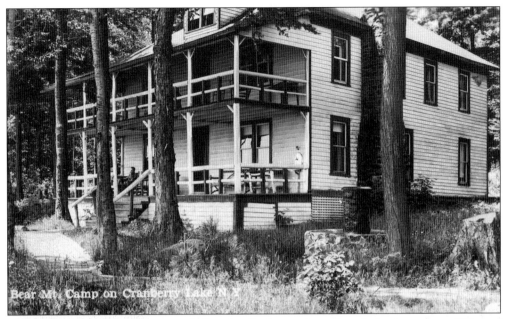

The Bear Mountain Camp annex was built to handle the overflow of tourists and sportsmen. This card states, "Barb and I have got our bucks. Got one today that will go over two hundred easy. Seeing lots of deer and having a fine time." Balderson sold the camps to Howard Jeffries in 1946. Later owners extensively remodeled both buildings. They remain in use as private camps, but the boathouse is long gone.

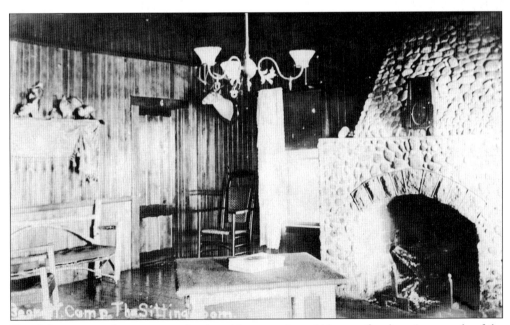

The sitting room at the annex was dominated by a massive cobblestone fireplace. An example of the carbide lighting system, a fine three-lamp chandelier, hangs from the ceiling. Underwater cables now supply electricity to camps in this area, known as Union Point.

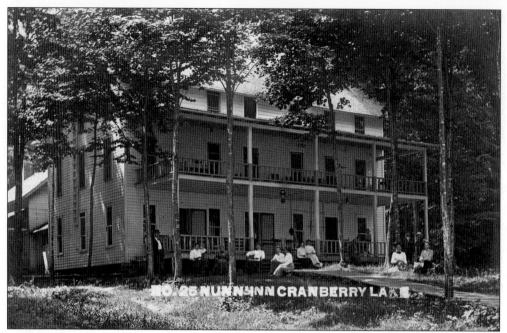

Nunn's Inn was built in 1898 by George Nunn, who ran it until his death in 1910. Located on the south shore of the lake at the foot of Indian Mountain, the main boardinghouse, seen here *c.* 1905, also contained a bar and poolroom. Behind this building were the kitchen, dining room, guide house, woodshed, barn, gardens, cow pastures, rifle and pistol ranges, a trapshooting blind, and tennis courts.

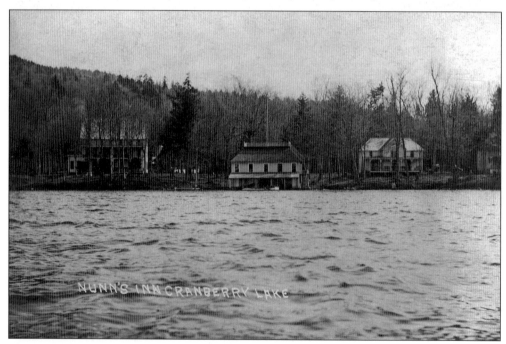

This view from the lake shows some of the buildings that made up the complex at Nunn's Inn. The main inn is to the left. The boathouse is in the center, with the inn annex to its right. The inn also owned a cottage to its east, the McDonald. West of the annex were the Birch, Wildcliffe, and Spruce cottages.

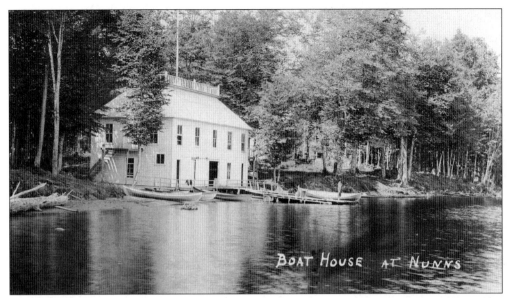

The large boathouse at Nunn's Inn had a workshop on the second floor. A ladder to the roof provided a fine view from the small flat top. The inn maintained a fleet of sturdy guide boats, seen here drawn up on the beach. Guests rowed around the lake or were rowed by a guide. Few canoes were provided, as these were considered unseaworthy and required too much skill for tourists. The boathouse and the adjacent annex are now private camps.

In 1911, Richard Jesup, a wealthy sportsman, bought Nunn's Inn and organized the exclusive Indian Mountain Club. Dues were $1,000 per year. Members commuted from New York City on weekends, while their families spent the summer. Hunting and fishing rights were leased on thousands of acres, but the club never prospered. Most of the property was sold in 1917. In 1926, the main clubhouse burned. The log cabin seen in this 1912-postmarked card was the grill room, an addition to the dining hall.

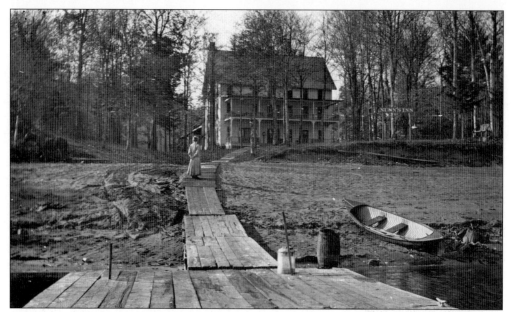

The dock at Nunn's Inn extended at least 80 feet into the lake. This was necessary to allow for extreme seasonal variations in the lake level. The message on this card, postmarked in October 1908, states, "We have been watching the fires on the mountain west of us; if we get a wind there will be a lot of timber destroyed." The writer refers to the burnover of nearby Cat and Round Top Mountains, which nearly reached the lake.

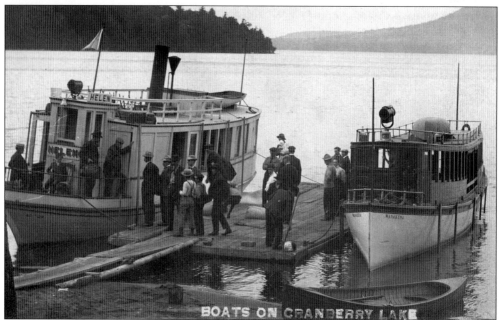

The steamer *Helen* (left) and the motor launch *Wanakena* (right) are seen docked at Nunn's Inn c. 1910. They made up the fleet of the Cranberry Lake Transportation Company, under several owners. These boats made daily trips around the lake, starting at Cranberry village and stopping at all hotel and cottage docks with passengers, freight, and mail. They reached Wanakena around noon to connect with the train from Benson Mines and then made the return trip to the village.

This *c.* 1905 view shows George Preston, head guide for Nunn's Inn and the Indian Mountain Club. Up to 20 guides worked here at a time; they made the city guests' vacation a success. They planned trips, rowed and carried guide boats, toted loaded pack baskets for miles, found trout or deer, cleaned and dressed game, built camps and fires, cooked meals, washed dishes, and told tall tales—all for $3 per day. In the winter, guides often worked for lumber companies.

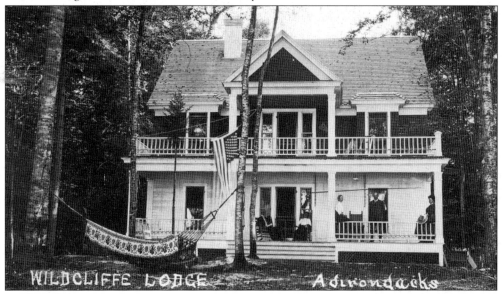

This is the original Wildcliffe cottage (built *c.* 1900 to the west of Nunn's Inn) and part of the complex. After many years in use as a sporting and tourist lodge, it is now privately owned but has been so extensively remodeled that it bears little resemblance to this view.

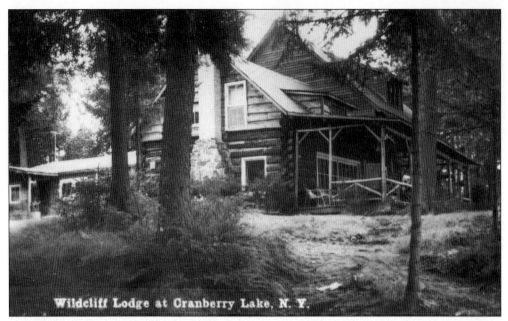

Wildcliff Lodge at Cranberry Lake, N. Y.

The Wildcliffe began to change when Richard Jesup moved a log cabin from Big Deer Pond, several miles south of the Indian Mountain Club, to adjoin the cottage. The cabin was built by hermit-guide Fide Scott. It was dismantled and then reassembled on its new site, the logs having been numbered for reference. It is seen in the foreground of this 1940s view, serving as the dining room. By this time, the Wildcliffe had been completely rebuilt with materials salvaged from the razing of the Columbian Hotel.

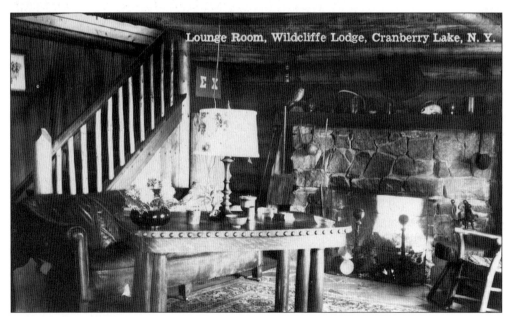

Lounge Room, Wildcliffe Lodge, Cranberry Lake, N. Y.

Rugged leather and hobnail furniture are prominent in this card of the lounge room at the Wildcliffe Lodge. A bear's head is mounted over the fireplace mantle, which displays other sporting trophies. The outside round-log wall appears so well fitted that little chinking would have been required.

34

This *c.* 1910 view looks north from Nunn's Inn toward Buck Island, less than a mile away, with Bear Mountain in the distance. The white boathouse at Bear Mountain Camp can barely be seen at its foot. Buck Island, circular and about 21 acres in size, was the largest island in the original lake. After the state dam raised the water level and flooded a peninsula, Joe Indian Island became the largest.

NO. 27 BUCK ISLAND COVE.

Judge Irving Vann, of the Syracuse Supreme Court, built a large summer home on Buck Island in 1895. The island and camp are still owned by family members. The main camp, surrounded by trees, could not be seen from the lake—by design. Passing boat traffic could only glimpse the landing cove and admire this rustic cabin and bridge.

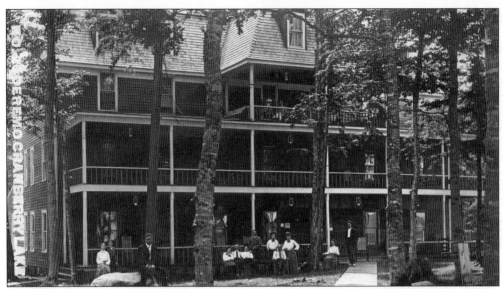

The Deremo Hotel was built in 1903 by Ed Deremo on a point west of Buck Island. It was a large, rambling, four-story structure with full open porches. The main timbers were hewed from large spruces growing along the shore. The hotel was popular mainly with summer tourists, brought in via the Cranberry Lake Railroad from Benson Mines to Wanakena and then by boat to the hotel.

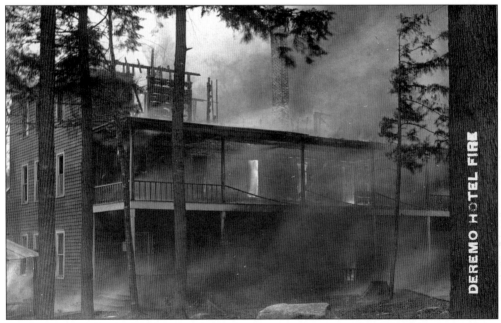

The Deremo Hotel had a short history; it burned to the ground on November 2, 1907. It seems odd that a photographer was on hand to record its demise, but the card's publisher, H.L. Locke of Harrisville, specialized in views of this area and may have been in the vicinity. Several private cottages that were built nearby by Deremo and others are still in use.

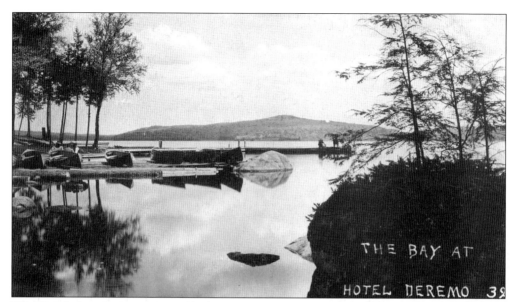

Like Nunn's Inn, the Deremo Hotel had a substantial dock to accommodate the larger steamboats and launches, as well as an array of guide boats. The view was excellent, a sweeping vista at the widest part of the lake.

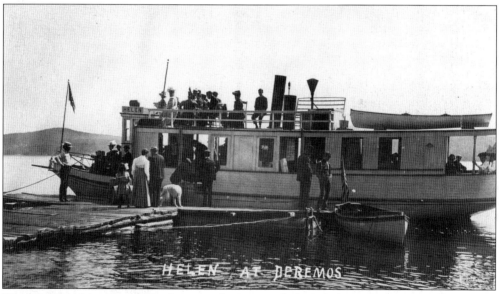

The wood-burning steamer *Helen* is seen at the Deremo dock in this *c.* 1905 view. One of the earliest mail boats on the lake, it replaced the 1870s steamer *Howlett,* owned by Riley Bishop of Bishop's Hotel. Besides daily mail and passenger service, the *Helen* offered a popular 35- to 40-mile excursion trip on Sundays. The *Helen* soon gave way to more modern craft but continued in use towing rafts of logs around the lake.

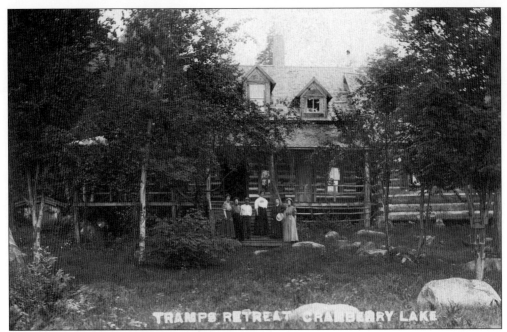

TRAMPS RETREAT CRANBERRY LAKE

Tramps Retreat was located on the north shore of Dead Creek Flow. The two-story log camp was built in 1886 for Ames Howlett and Albert Hiscock by a crew of the best local ax-wielding woodsmen. While not a commercial inn, it still became a famous sportsmen's retreat, hosting Frederic Remington, author Irving Bacheller, and Gov. Roswell Flower. Ames Howlett, a world traveler, furnished the interior with curios, animal trophies, and traps of all sizes. The camp grew into an impressive establishment with a six-bedroom main camp, large dock and boathouse, icehouse, woodshed, pump house, springhouse, chicken coop, dove cote, and guide house. It was fully staffed with cooks, handymen, servants, and guides. Tramps Retreat was sold to the Moore family in 1916. It was destroyed by lightning and fire in April 1957. Descendants of the family still own the property and surviving outbuildings.

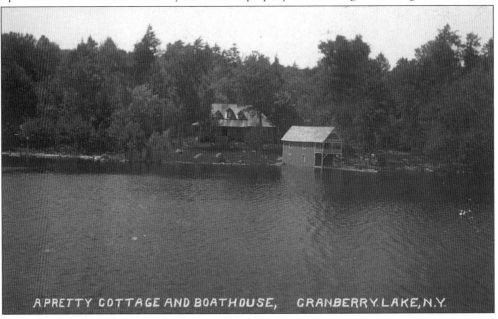

A PRETTY COTTAGE AND BOATHOUSE, CRANBERRY LAKE, N.Y.

Not every building on the lake was a large hotel or elaborate "camp." As seen in this June 1905 card, many were of simple construction. Pictured in front of this cabin is one of Cranberry's earliest residents, Steven Ward, who first visited the lake as a boy in 1844. After the Civil War, he became a guide and operated a tent campsite—Camp Uncle Sam, located on the upper Oswegatchie River. "Uncle Steve" Ward died in 1928, a venerable 91 years old.

A 1915 Cranberry promotional brochure declared, "Any great lover of the Wilderness prefers to dwell in tents, or open camps, during the vacation season." Plus, on a practical note, it saved money. State land was open to campers, and the state cleared tent sites and built lean-tos at choice locations. This island in Dead Creek Flow appears to have had two of them. Islands were favorite camping spots, as they tended to be bug-free.

The Cranberry Lake Motor Boat Club was organized in 1909. According to Commo. James Foster Wilcox of North Adams, Massachusetts, the club was founded "to promote the healthful sport of power boating, and the advancement of social relations among summer visitors and residents." In this *c.* 1912 card of club officers, Wilcox is pictured in the center. To the far left is Richard Jesup of the Indian Mountain Club.

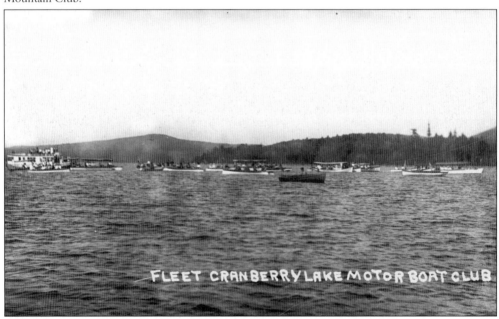

The boat club sponsored an annual regatta and field day that was held about August 10. The fleet is shown in this 1911-postmarked card. The regatta was the big social occasion of the year. Crowds came by railroad, with cottage owners, campers, tourists, and motorboat fans all joining in. Boat racing and baseball games were followed by a picnic. Band concerts, fireworks, and dancing occupied the evening. The Cranberry Lake Boat Club continues today.

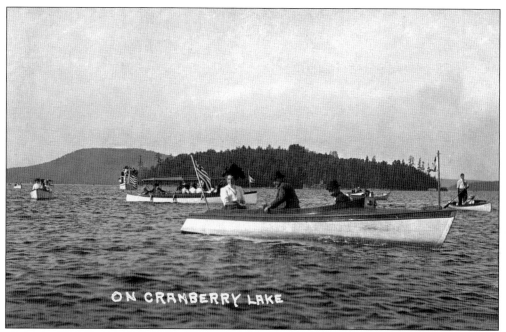

ON CRANBERRY LAKE

The boat club's regatta-day activities were held in part at Nunn's Inn and the Indian Mountain Club. This view looks north to Buck Island. Directly behind the woman's boat is the tour boat *Oklawaha*, of Wanakena. These early motorboats all had inboard engines, powered by gas or naptha, a kerosene-gas mix. Small boats required careful use on this large, shallow lake, prone to quick-rising, wind-driven waves.

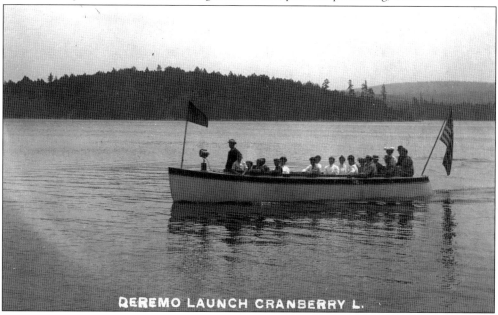

DEREMO LAUNCH CRANBERRY L.

Most of the larger inns had their own motorboat and hired local men as pilots. This job also included tuning their engines and polishing the mahogany trim and brasswork. The Deremo Hotel's launch was 35 feet long and 6 feet wide. It had a large, three-cylinder inboard motor and often sported a tasseled top. Twenty or more passengers could be seated. After the Deremo burned in 1907, the Indian Mountain Club purchased the launch and renamed it the *IMC*.

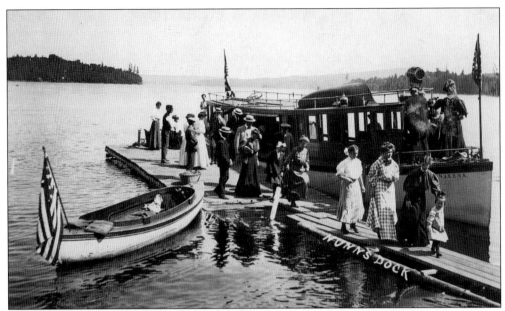

The Rich Lumber Company of Wanakena brought its gas-powered launch *Wanakena* to Cranberry *c.* 1905. It is seen here at the Nunn's Inn dock. The *Wanakena* carried summer tourists and the "fast mail" (about 15 miles per hour) to camps and hotels. It was the largest of its type on the lake. Capacity was about 100 passengers. After the Rich Lumber Company left the area in 1912, the company sold the *Wanakena* to the Howland Brothers, owners of the *Helen*.

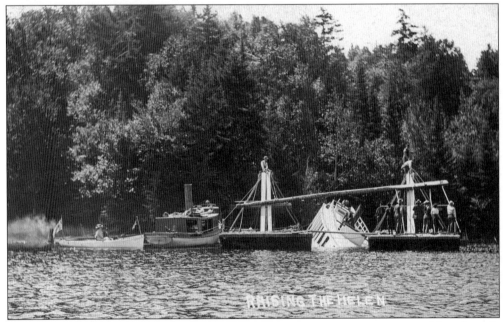

A boat ride on Cranberry sometimes provided more excitement than passengers bargained for. The early lake was full of logs, stumps, and other debris, even in the main channel. The steamer *Helen* sank occasionally by ramming a log through its hull. In this *c.* 1908 card, two barges and men with chains and jacks are "raising the *Helen*." By 1920, the boat's owners had tired of this yearly ritual and permanently scuttled the *Helen* in LaFountain Bay, on the west shore.

Three
CRANBERRY LAKE LUMBERING

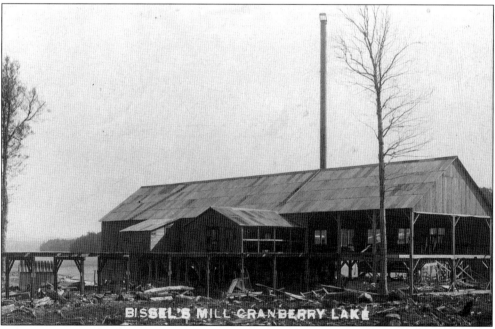

The earliest lumbermill operation at Cranberry village was the Bissell Brothers steam sawmill, built in 1904 by Dana and Brahm Bissell. Its boiler was fired with sawdust and waste slab wood; note the cinder trap on top of the smokestack behind the mill. The mill was located on a small point just west of the Evergreen Hotel and across the road from the Windsor Hotel, also owned by the brothers. The mill sawed its last log before World War I, and the peninsula is now occupied by Campers Village, renting camping trailers and sites to tourists.

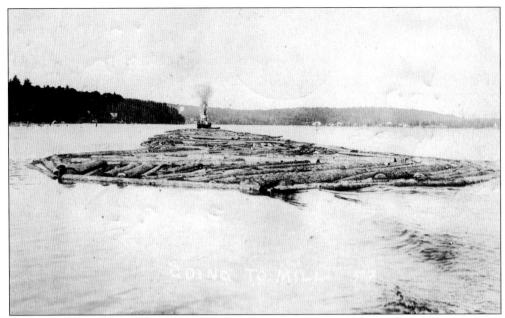

This 1907-postmarked card shows softwood logs being towed to the Bissell mill by the black-and-yellow steam tug *Griffin,* also known as the *Ironclad.* The log boom was about a half acre in size and could take up to two days to travel the six miles from the head of the lake to its foot. Still, some logs jumped the boom and were left floating in the lake. Lumber companies offered bounties for their return.

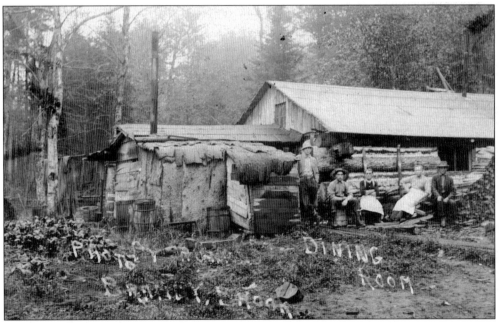

The dining room and cook shack of a lumber camp on Brandy Brook Flow are pictured *c.* 1910. The area was being cut for pulpwood by International Paper, which sluiced logs through the dam to the Newton Falls paper mill downstream. The aproned cook and his assistant, the cookee, are both male. Meals tended to emphasize quantity over quality. The basics at meals were meat, potatoes, baked beans, flapjacks, eggs, bread, pie, and coffee.

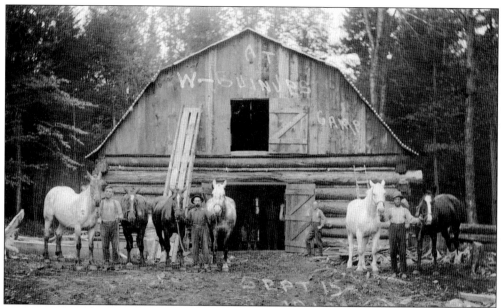

This September 15, 1912 card shows one of Warren Guinip's lumber camps at Cranberry. Guinip was a well-known jobber, or contract logger. A jobber built roads and camps, supplied them, and chose the crews. His own management of the operation (and luck) determined any profit. Most important was the care of the logging horses, and drivers often slept with their teams. Guinip tells his own story in *Cranberry Lake from Wilderness to Adirondack Park,* edited by Albert Fowler.

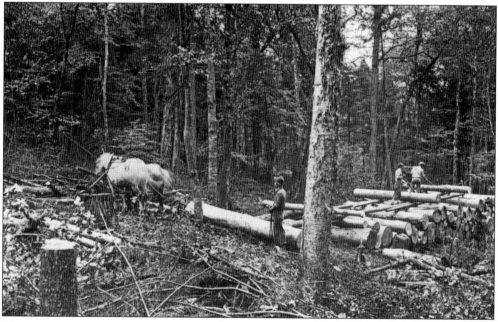

The state education department produced this 1913 view (originally a magic-lantern slide), titled "Skidding Softwood Logs in Summer near Cranberry Lake." The loggers are building a skidway from spruce logs, peeled to lighten them. "Swampers" would first cut out the skid roads. Trees were then felled with axes and crosscut saws, and horses hauled the logs to a skidway, a raised stack of logs that allowed easy loading on sleds during the winter.

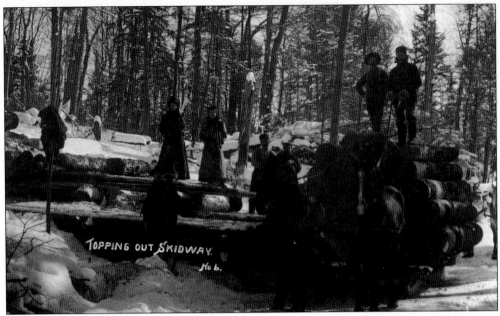

These two views were taken in the area between Cranberry Lake and Newton Falls. The upper card, postmarked 1908, shows winter work at a skidway. Logs were hauled on iced roads via sleds, either to banking grounds for spring floating or to be delivered directly to railroad cars. Postmarked 1913, the lower view of a "model lumber camp" labels the office (which usually included a small store), the stable, the men's camp (sleeping 40 to 50 bug-ridden lumberjacks), the cook camp (which also contained winter storage for root vegetables), and the outside cellar (for storage of frozen meats). The snowplow was based on a field plow, with added boards to scrape and smooth the roads. The sprinkler tank would follow the plow to make a hard, icy road so slippery that "sand monkeys" were needed to sand the downgrades, keeping the loads from breaking away and running over the horses.

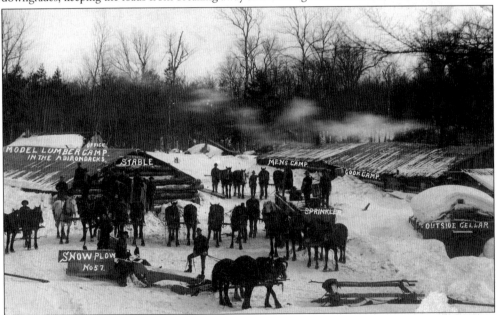

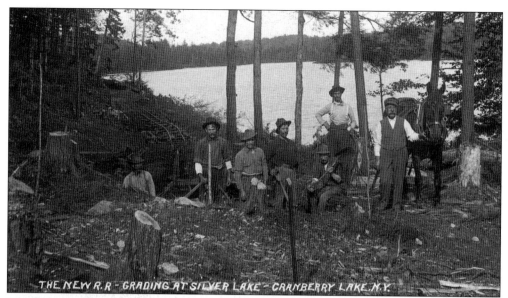

THE NEW R.R - GRADING AT SILVER LAKE - CRANBERRY LAKE. N.Y.

The Emporium Lumber Company began moving its operations from Pennsylvania in 1905, making large land purchases in the Adirondacks. Emporium's first New York mill was built in Conifer in 1911. Between 1911 and 1913, it constructed a main line railroad 16 miles west to Cranberry Lake. The Grasse River Railroad was built for logging but, in 1915, incorporated as a common carrier to allow hauling of passengers, freight, and mail. In the upper card, Italian laborers work to construct the main line along the shore of Silver Lake, just north of Cranberry village. The lower card, dated 1923, shows a yellow birch log being swung into place in front of a locomotive on the North Tram, near Pleasant Lake. The North Tram was a network of logging lines extending 30 miles north of Cranberry. It was closed in 1941, and the main line was taken up in 1948. (Below courtesy Adirondack Museum.)

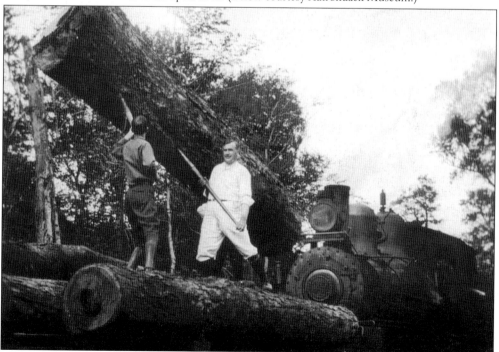

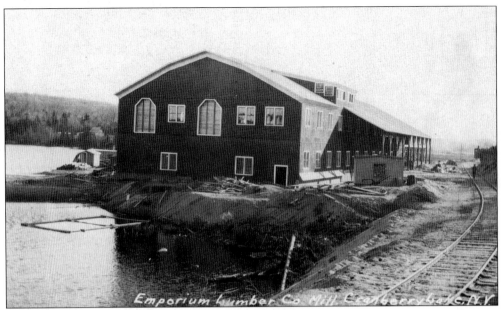

Under company president William L. Sykes, "the Hardwood King," the Emporium Lumber Company bought 125,000 acres in the Cranberry region. Most had already been logged for softwoods by International Paper. Nearly all the maple, cherry, birch, and beech sawn at Emporium's Conifer and Cranberry mills came from its own lands. The demand for lumber around World War I inspired the company to build this large double-band sawmill in 1917, on the southwest shore of Silver Lake at Cranberry village. During its 10 years of operation, it turned out at least 200 million board feet of lumber. The high-quality product brought a premium price on the market, with most going for flooring, or to furniture manufacturers. The mill closed in 1927, and its machinery was moved to Conifer. Between 1930 and 1949, Emporium sold its cut-over timberlands to the state and to other wood-industry buyers.

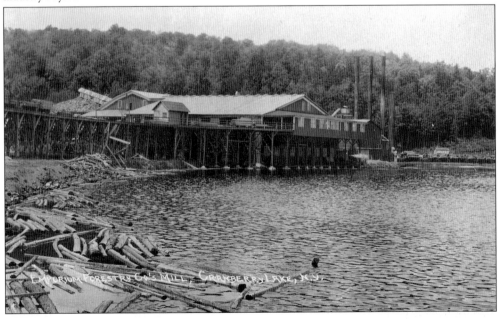

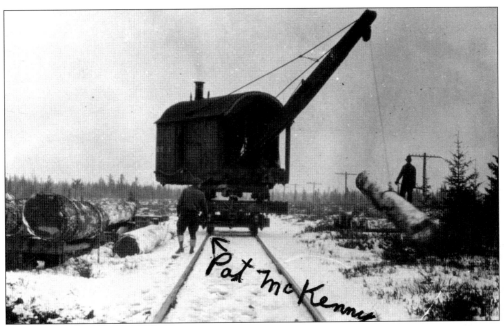

Pat McKenney, Emporium Lumber Company forester, directs the operation of a Barnhart log loader in this 1920s view. A maple log is being raised from a skidway to be loaded onto a log train. The Barnhart, named for its inventor in 1895, was a very practical steam-powered loader. It sat on top of the log cars and winched itself along them by cable, on rails built on the cars. Emporium had four Barnhart loaders.

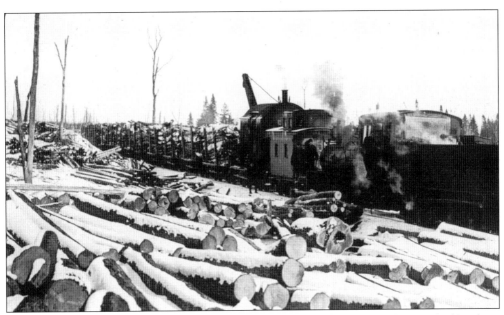

After loading a car, the Barnhart would winch itself ahead one car and then load the car it had just been sitting on. It continued until it reached the end of the train. This view shows the final stage of the operation. Locomotives pushed trains of 20 loaded log cars to the mills at Cranberry or Conifer. Boxcars of lumber from the Cranberry mill were also pulled to the New York Central junction one mile east of Conifer. (Courtesy Adirondack Museum.)

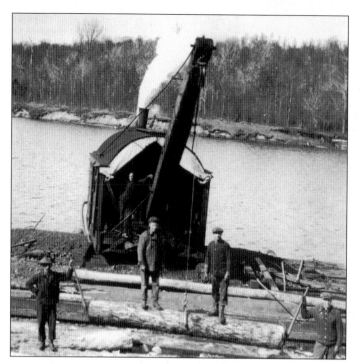

When the Emporium Lumber Company logged the area south of Cranberry, logs were towed to the village on rafts and loaded onto cars on the Grasse River Railroad. This 1920s scene in South Bay shows a Barnhart loader sitting on a float. The raft, made of spruce logs, is in the foreground. Hardwood logs floated poorly, so softwoods were put under them. This method, however, did not work well in practice and left many stray logs floating just under the surface. (Courtesy Adirondack Museum.)

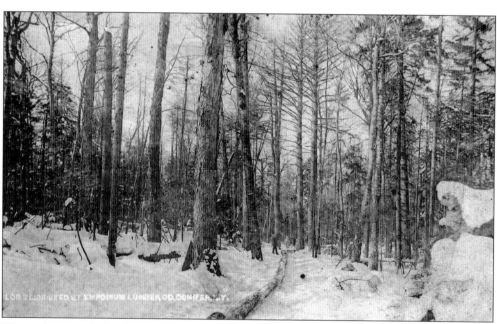

This card, postmarked in January 1918 at Conifer, shows a log slide in use east of Brandy Brook Flow. A portable slide was invented by Frank Sykes, the Emporium Lumber Company's woods superintendent. The slide was made from sections of three eight-foot slotted boards, assembled to form a trough and joined together. A train of logs was pulled along the greased slide by a team, with one horse on each side. The message notes, "Very cold here, zero to 45 below all the time."

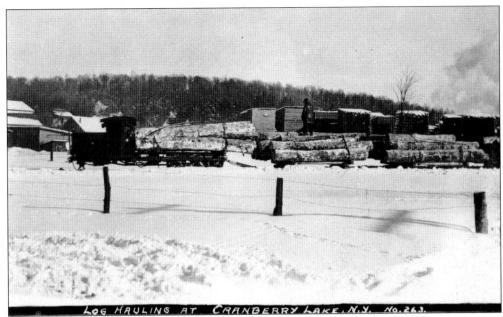

By the 1920s, the Emporium Lumber Company was using its four Linn tractors to log the large area east of Cranberry. The one shown is No. 4. The Linn, manufactured near Utica, was one of the earliest woods tractors, gas-powered with rear crawler tracks and front steering runners. Each could haul six to eight loaded sleds to a railroad station or the Cranberry mill. Teams of horses continued in use for skidding short hauls and light loads.

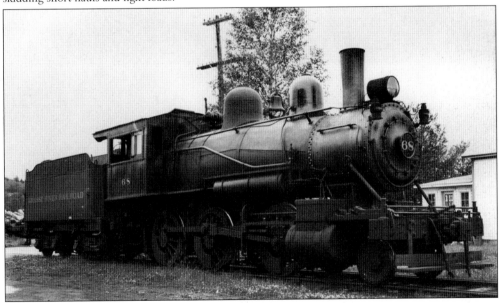

This view from June 1936 shows Schenectady No. 68 at Cranberry village. It was a 60-ton rod locomotive and was used on the Grasse River Railroad main line. Jokes regarding the vintage of the Emporium Lumber Company's engines moved the company to deny that any dated from the Civil War. Still, Emporium did employ a variety of cranky steam locomotives dating from the 1880s and 1890s, such as No. 68. *Rails in the North Woods* (by Allen, Gove, Maloney, and Palmer) is recommended to readers interested in railroad history.

An old-growth white pine, the tallest Adirondack tree, is pictured near Cranberry in this 1910-postmarked card. These trees, along with spruce, attracted the first loggers. The largest pines left in the region measure some 150 feet tall and 5 feet in diameter, at several hundred years old. Individual white pines tower over the canopy south of Wanakena. Larger stands can only be found south of Five Ponds and High Falls.

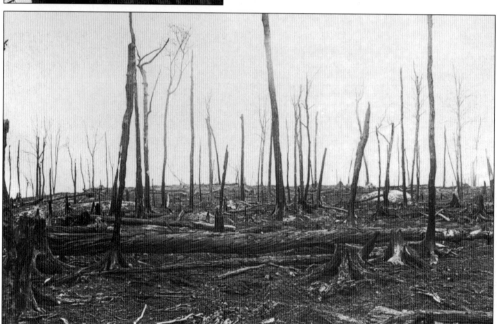

This magic-lantern slide from the state education department is captioned "Surface of Ground after a Severe Fire, 1908, Long Lake West." This was often the result of early logging operations. The Great Fire of 1908, the worst to occur in the Adirondacks, was started by sparks from a locomotive. It was fueled by huge piles of dry tops and branches left in the woods. The fire swept from Sabattis, eight miles west to Cranberry Lake, often burning to the bedrock.

Four
HIGHLIGHTS OF THE CRANBERRY LAKE REGION

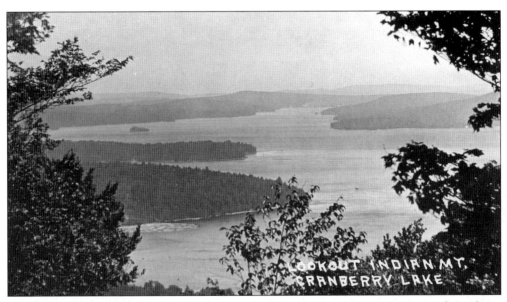

The Indian Mountain Club leased the hunting and fishing rights on 12,000 acres around Cranberry Lake. The club cleared many trails on its lands to ponds and other points of interest. The trail to the summit of Indian Mountain, a mile south of the club, was popular for its sweeping view. It was heavily marked with red blazes and nicknamed the Bloody Trail. In this view (looking north from the summit), Deremo Point is in the foreground, with Joe Indian Island above it. Cranberry village is in the far distance, at the northern end of the Main Flow.

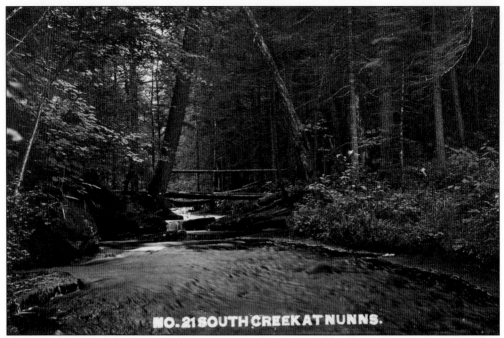

NO. 21 SOUTH CREEK AT NUNNS.

Another appealing day hike from the Indian Mountain Club led south along Sixmile (or South) Creek. This was one of the most scenic hikes in the region, at least before logging began. Passing over the bridge, the trail led in less than two miles to Sliding Rock Falls, seen below in a 1913-postmarked card. The creek drops about 15 feet at the falls over a wide, sloping rock. According to local lore, this was the point beyond which no tourist—or "hopsooner," as the natives called them—should dare venture without a guide. Guides told stories of strange animals and mysterious places to amuse children, but city-bred tourists often had trouble telling fact from fiction in the dark woods. It was better to hire a guide. Sliding Rock Falls is still a popular destination, and the land is now part of the Five Ponds Wilderness Area.

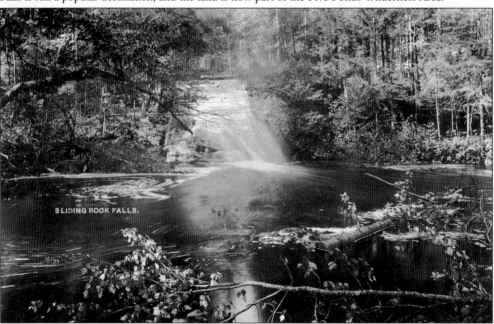

SLIDING ROCK FALLS.

Joe Indian Island was a peninsula of Cranberry Lake before the dam but became the largest island in the lake after the flooding. In May 1909, when owner Walter Mullen of Buffalo offered the island for sale, his advertisement stated that "Joe Indian Island is an Ideal Summer Hotel and cottage site proposition." However, New York State bought the more than 100-acre island in its entirety.

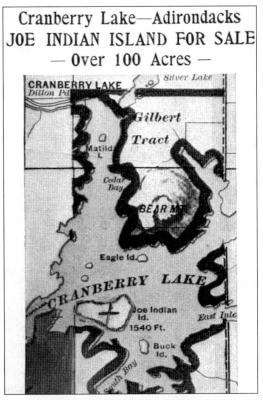

Cranberry Lake—Adirondacks
JOE INDIAN ISLAND FOR SALE
— Over 100 Acres —

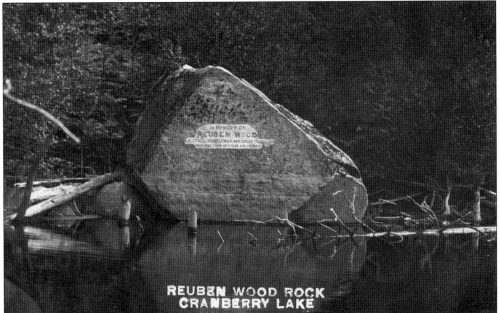

REUBEN WOOD ROCK
CRANBERRY LAKE

Reuben Wood (1822–1884), who ran a sporting-goods store in Syracuse, was a world-champion fly caster and designed the trout fly that bears his name. He spent many summer vacations at Cranberry, camping at East Flow. In 1895, his friends had an inscription cut into a rock at the mouth of Sucker Brook: "In Memory of Reuben Wood, a genial gentleman and great fisherman who was fond of these solitudes."

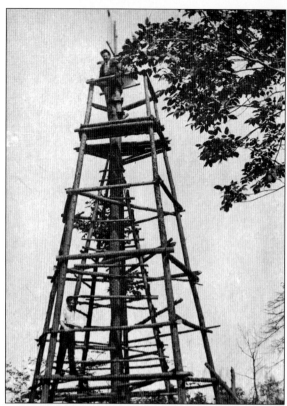

At 2,160 feet, Bear Mountain is one of the largest of the region's relatively low mountains. This wooden fire tower and signal station on the summit was a favorite day hike for tourists—two are pictured climbing the rickety-looking tower in this 1905 card. The swinging tin sheets at the top of the tower were used by survey crews as a sighting point; this device, known as a Stan-Helio, was invented by state surveyor Verplanck Colvin. The tower was demolished before 1920 and was never replaced.

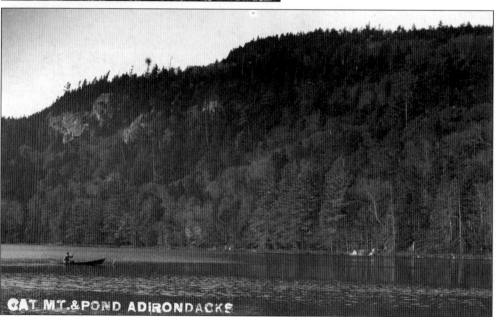

CAT MT.&POND ADIRONDACKS

In the early 1900s, a hike up Cat Mountain was a must for tourists staying at area hotels. Guides would lead parties up the mountain, from either the landing at the southern end of Dead Creek Flow or by trail from Wanakena. Cat Mountain Pond is due south of the summit, below cliffs that have long been occupied by nesting ravens.

The disastrous forest fires of 1908 led to the construction in 1909 of a fire tower on the summit of Cat Mountain. The original wooden tower was similar to the one on Bear Mountain. It was replaced in 1917 by this 50-foot steel tower. The small stand to the right may date to Verplanck Colvin's survey of the region in 1873. The Cat Mountain tower, made obsolete by helicopter flights, was dismantled in the 1970s.

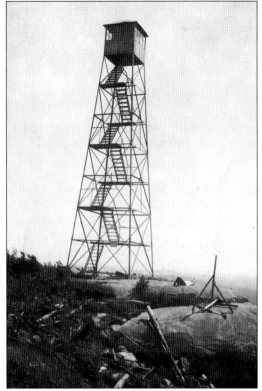

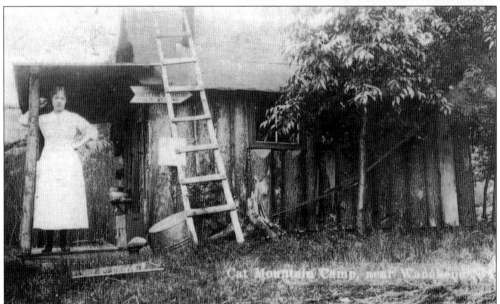

From 1909 to 1934, the Cat Mountain tower was manned by John Janack, who lived with his family in a house at the landing on Dead Creek Flow. Janack climbed to the tower daily, despite the loss of an eye and leg in a 1908 explosion at Benson Mines. The state eventually built this fire observer's cabin for him near the summit. The sign reads, "Cat Mt. Forest Fire Observatory—Public Welcome." This cabin, too, has been demolished.

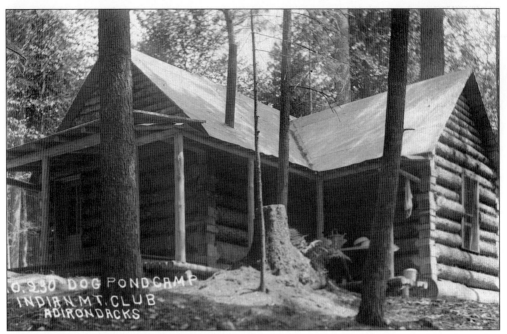

The Indian Mountain Club controlled the fishing on many small ponds, and camps were maintained at Brandy Brook, Darning Needle Pond, Cat Mountain Pond, Big Deer Pond, and Dog Pond (considered the most scenic). The trail to Dog Pond left East Flow and, after about three miles, emerged at the northwest corner of the pond. The club's camp was hidden in the pines behind the large rock on the east shore. All of the camps had the same design—one large room served as kitchen, living, and dining area; wings on two sides held four bunks each. The camps were stocked with bedding, staple foods, rowboats, and canoes. They were staffed with a guide who also served as a cook and caretaker, so guests needed to bring only fresh supplies and their sporting gear. Pictured *c.* 1912, the Dog Pond camp was, like all the others, demolished when the state bought the land.

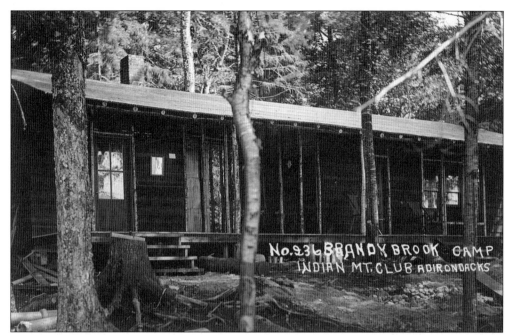

Brandy Brook Flow was the greatest fishing destination on the early lake, and many record trout were taken. Guide Barney Burns built a simple lean-to in the 1880s on the east shore of the flow. It was later expanded and, from 1890 until his death in 1901, was a popular sportsmen's retreat. The Burns camp was succeeded in 1912 by this new camp, built by the Indian Mountain Club. Only its stone chimney remains.

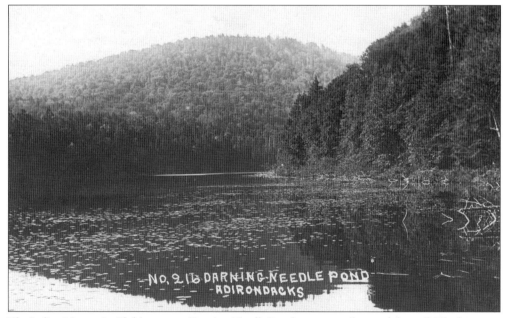

The Indian Mountain Club's camp at Darning Needle Pond was two miles south by trail. The log camp (identical to the one at Dog Pond) was located on the west side of the half-mile-long, narrow pond. It cannot be seen in this view, looking south from the outlet to Wolf Mountain. The pond's name could come from either the dragonfly or from the long needle used for darning.

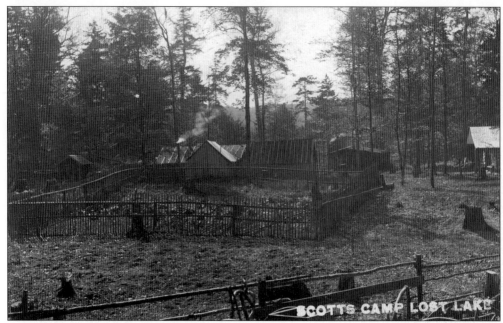

The Indian Mountain Club maintained camps at Big Deer Pond, also called Lost Lake by Verplanck Colvin, about five miles south of the club. They were first occupied in the late 1800s by Philo "Fide" Scott, famous hermit and guide, who built his home out of the best hand-hewn logs from an old lumber camp on the site. After Fide's death in 1911, Richard Jesup moved this log cabin by sled in winter, first to Cat Mountain and then to adjoin Wildcliffe Lodge. The remaining buildings at Big Deer (a sleeping cabin, dining camp, and barn) continued in use by the club. These cards are postmarked 1909, when the camps were still occupied by Fide Scott. "Uncle Fide" stands to the far right in the lower card, picturing the sleeping cabin and hunting guests. Note that the fireplace chimney is made of wood poles, an incredible fire hazard. No trace of these structures remains today.

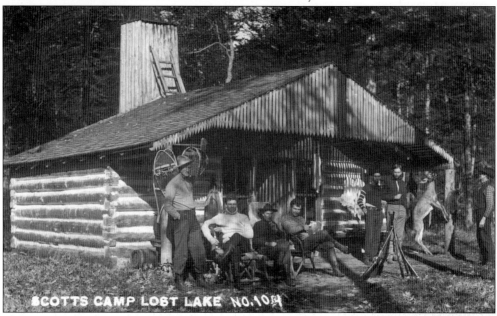

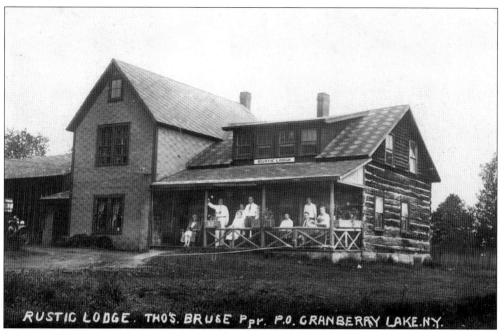

RUSTIC LODGE. THO'S. BRUCE Ppr. P.O. CRANBERRY LAKE.N.Y.

Rustic Lodge is located two and a half miles northeast of Cranberry Lake, near the Grasse River. The original hewn-log cabin was raised in 1878 by John Mills (builder of the Cranberry dam) and guide George Bancroft. They named the property Maple Grove Farms. After 1884, it was known as Clark's Farm, for owners Henry and Lucelia Clark, who boarded lumberjacks and their horses. The farm was sold in 1921 to Thomas Bruce, who renamed it Rustic Lodge and began catering to sportsmen. After a succession of owners and expansions, the complex retains the Rustic Lodge name. These 1920s cards show the original log cabin at the center of the main lodge and dining room. The smaller camps are lined up along the entrance road. These were popular rentals with deer hunters. The lower card notes, "George wants to tell you we are coming home with some bucks."

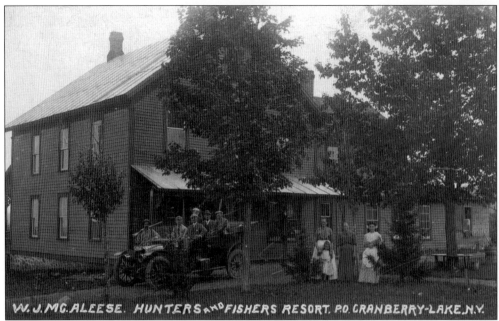

W.J.MC.ALEESE. HUNTERS AND FISHERS RESORT. P.O. CRANBERRY-LAKE.N.Y.

The Mountain House was also located near the Grasse River, two miles north of Cranberry Lake on the Windfall. The Great Windfall, a series of small tornadoes, swept upstate New York in 1845. William "Mack" McAleese and his wife, Elizabeth, came from Ireland in the 1890s to work here for the Canton Lumber Company. They soon purchased their home from the company and began boarding up to 40 loggers at a time. As lumbering waned, McAleese became a popular and entertaining guide. His wife was equally renowned for her cooking. Square dances helped fill the winters, which were so long (as McAleese remarked) that the Fourth of July did not come sometimes until late in August. These two *c.* 1910 cards are of the same hunters, with a trophy 14-to-16-point buck propped in the back seat of their touring car. Mack is standing behind the car in the card above. Below, he is in front of it.

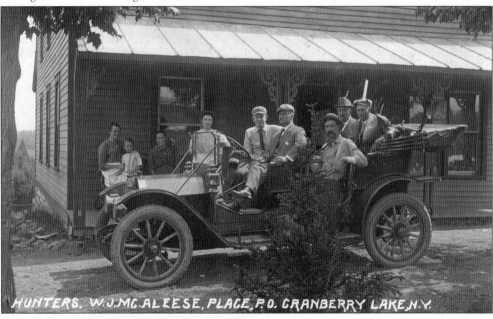

HUNTERS. W.J.MC.ALEESE, PLACE, P.O. CRANBERRY LAKE.N.Y.

62

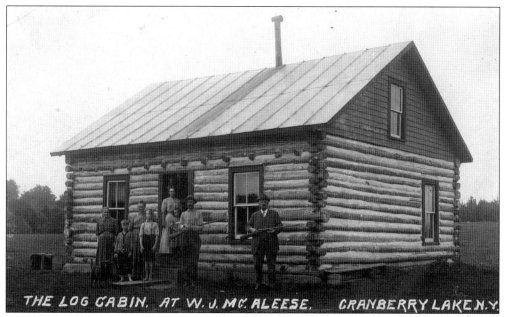

THE LOG CABIN, AT W. J. MC. ALEESE, CRANBERRY LAKE, N.Y.

In this view, William McAleese is pictured second from the right, in front of the log schoolhouse that he built for his six children and for those of other Windfall families. He also hired and boarded the teacher, who is standing in the doorway. After McAleese bought the Evergreen Hotel and moved to Cranberry village in 1918, the Mountain House was rented to various tenants and was eventually torn down. The Cranberry Lake Fish & Game Club now occupies the site.

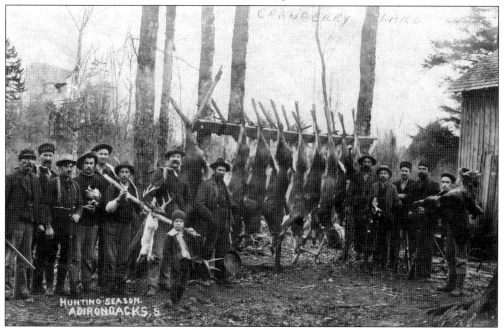

The exact location of the site shown in this card, postmarked in 1913 at Cranberry Lake, is unknown. However, it is a classic hunting scene, featuring 13 men (armed with 10 rifles), the camp cat, eight hanging deer, several racks, and a snowshoe hare. Two child helpers complete the picture. The view may have been taken at a woods camp maintained by the party's guides or by a local hotel.

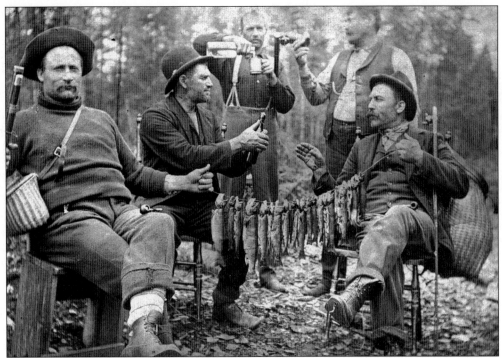

These Cranberry Lake fishermen's string of 20 speckled, or eastern, brook trout was not impressive by the standards of 1905, in the days of Cranberry's world fame. An advertisement for the Cranberry Lake Inn stated that "the lake is thronged with trout and contains no other fish." Catches of two to four pounds were the norm, with the record over six pounds. However, the small size of this catch has not dampened the group's celebration.

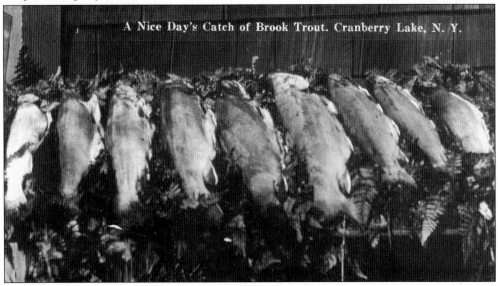

A Nice Day's Catch of Brook Trout. Cranberry Lake, N. Y.

By the time of this 1930s card, trout fishing was still excellent in the lake. The decline since has been blamed on many causes, including overfishing, beaver dams, and the introduction of perch and bass (all probably playing some part). Today, the brook trout in the lake are stocked. They are usually caught in the flows, as well as in headwater ponds and near High Falls on the upper Oswegatchie River.

Five

THE VILLAGE
OF WANAKENA

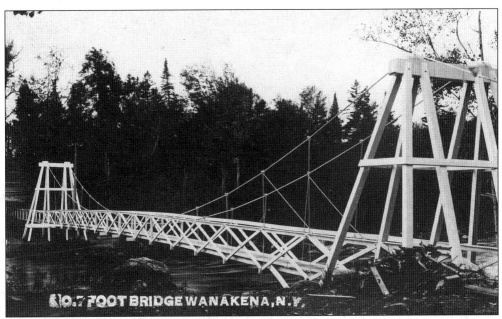

NO. 7 FOOT BRIDGE WANAKENA, N.Y.

In 1900, Wanakena was an unnamed campsite on the Oswegatchie River, at the point where it widens to become a flow of Cranberry Lake. In a few years, this was all changed. The Rich Lumber Company, owned by cousins Herbert and Horace Rich, had exhausted its timber resources in Granere, Pennsylvania. In 1901, the company purchased 16,000 acres on the southwest side of Cranberry Lake. In 1902, the company moved to create its new mill town, naming the site Wanakena. A suspension footbridge, seen in this *c.* 1908 card, was built for Rich Lumber Company workers. Measuring 170 feet between support towers, it connected Wanakena village on the north shore with the mill complex on the south side of the river. The bridge is still standing and, in 1999, was named to the National Register of Historic Places.

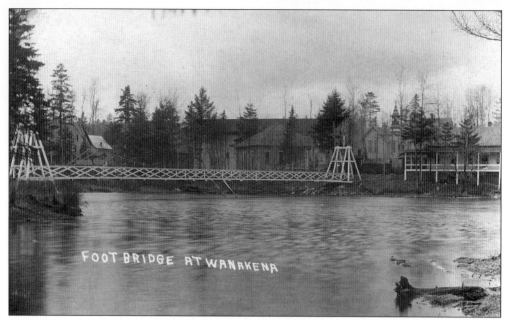

FOOT BRIDGE AT WANAKENA

By 1905, Wanakena was a modern village with electric lights, telephones, water and sewer system, post office, railroad depot, restaurant, two hotels, boardinghouse, general store, clubhouse, church, school, dance hall, pool parlor, shoe-repair shop, barbershop, ice-cream parlor, and meat market. The upper card looks north from the mills to the center of the village. To the far left is Conroy's Hotel. The Rich Lumber Company office is just west of the north bridge tower. The long building behind the office is the Rich and Andrews general store, and to the far right is the clubhouse. The clubhouse, seen below in a 1909-postmarked card, contained a recreation room, library, reading room, and, in the basement, bowling alleys. It was part of the Rich Lumber Company's efforts to encourage residents to spend their free time in wholesome activities, as the company prohibited the sale of liquor on its lands. The clubhouse and the office are now private homes.

READING ROOM
WANAKENA, N.Y.

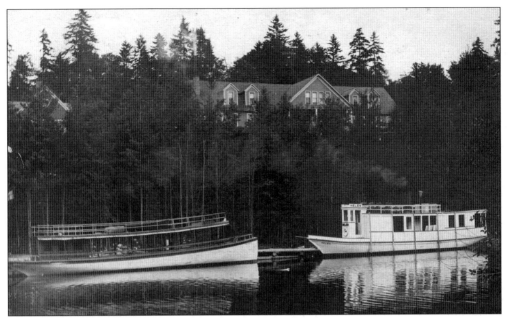

The Hotel Wanakena (seen above in 1905 and below in 1910) was one of the first buildings constructed by the Rich Lumber Company. Located at the east end of Front Street, the hotel originally consisted of the center section and two wings. In 1906, the east wing was enlarged, doubling the hotel's capacity. Steam-heated and open all year, it featured, according to advertisements, "Rooms En Suite and with Private Baths; Dining Room, Fireplaces, Parlor and Office. Write for booklet giving in full the beauties of the Forest Primeval. William H. Bean, Proprietor." William Bean managed the hotel until the Rich Lumber Company left in 1912. He was one of those born to run an inn. The Hotel Wanakena flourished as the "gateway to Cranberry Lake" and was very popular with New York City guests. They could board a sleeper car in the city on Friday night, spend the weekend in Wanakena, and be back to work on Monday morning.

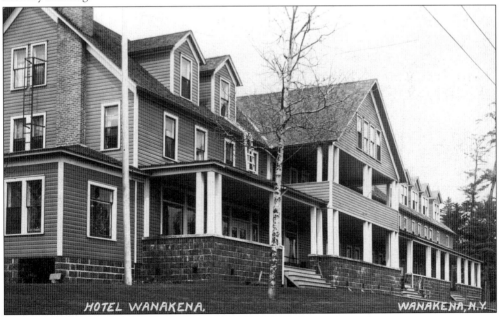

HOTEL WANAKENA. WANAKENA, N.Y.

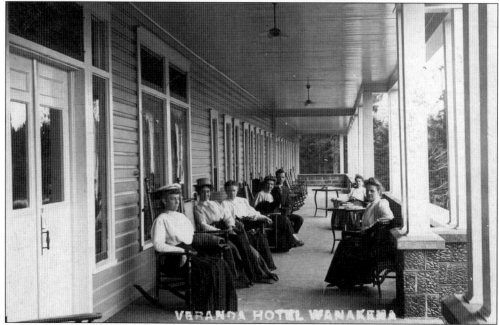

The message on this 1907-postmarked card notes, "This is a fine view of the veranda. The much-talked-of Muggins is on the arm of Mrs. Bean's chair." The wife of the manager, with her sociable black cat, is seated in the fourth chair from the left. Other proprietors followed William Bean, but none were as successful in attracting tourists, and business at the hotel slowly declined. It was demolished in the 1960s. All that remains is a set of stone steps.

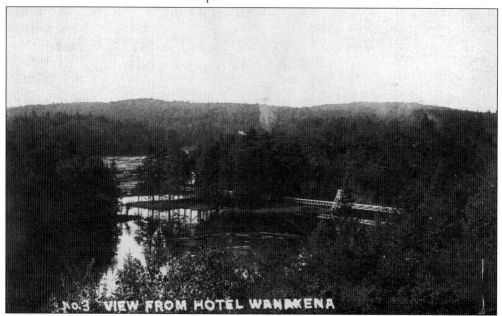

The Hotel Wanakena stood on high ground, and veranda sitters enjoyed a broad view over Inlet Flow. The worker's footbridge to the mill complex is to the right. Steam from the large sawmill is visible in the background on the south shore, as well as the millpond, full of logs. The loss of the "forest primeval" may have contributed to the hotel's decline.

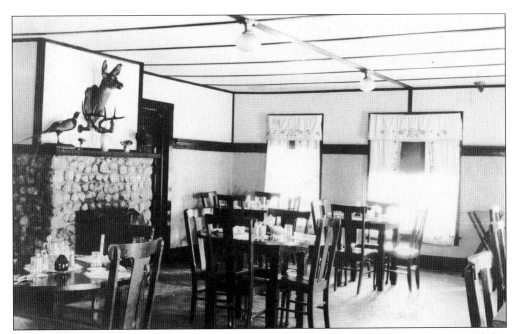

This card dates to the era of O.G. Rich, proprietor after William Bean. His advertisements stated that "the dining rooms at the Hotel Wanakena are unusually light, commodious, and pleasant. The linen and silver are nice, the service quiet and well-trained, and the menu excellent. . . . Large, open fireplaces with their blazing logs add much to indoor pleasure and comfort." The hotel's setting was also guaranteed to "arouse the appetite," so this dining room must have seen heavy use.

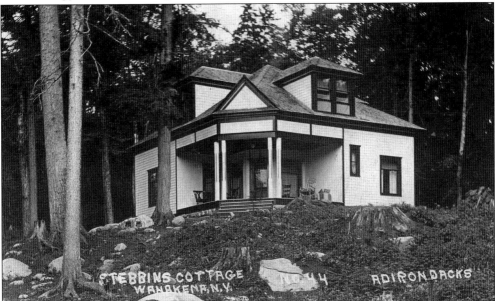

O.G. Rich's Hotel Wanakena brochure gushed on, "For those who prefer more quiet seclusion, a number of charming cottages, prettily situated adjacent to the hotel, well furnished and with electric lights, running water, baths, etc., may be rented at reasonable rates." The Stebbins cottage, located on the shore east of the main hotel, was one of these. This large cottage is still in use as a private camp and is virtually unchanged in appearance.

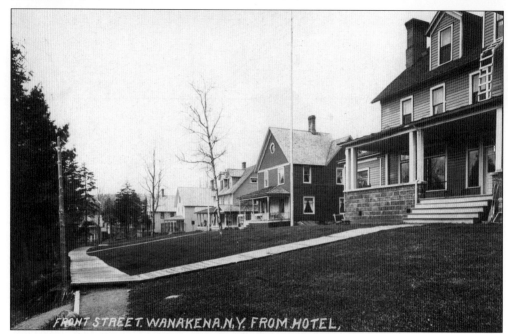

This *c.* 1910 card looks west down Front Street from the Hotel Wanakena. The Rich Lumber Company laid out the village streets in a simple plan, with Front Street running east–west along the length of the village, paralleling the river. First through Sixth Streets, numbered from east to west, branched north at right angles from Front Street. Most of the original three-story homes on Front Street, large dwellings built for company and mill management, are still standing.

This view looks east toward the Hotel Wanakena, from the corner of Front and Second Streets. It was taken between the general store and the depot. The building in the foreground is the post office, operated out of the home of the first postmaster, George Bullock. It is now used as a private camp. All of the streets in the village had hemlock-board sidewalks, which are now long gone.

70

This card looks north from the corner of Front and Second Streets, opposite the post office. The First Presbyterian Church, to the left, was brought from Pennsylvania by Rich in 1903 and reconstructed on site. Both the church and the Second Street homes pictured are still in use, but the fancy gingerbread trim on the church steeple has been lost over time.

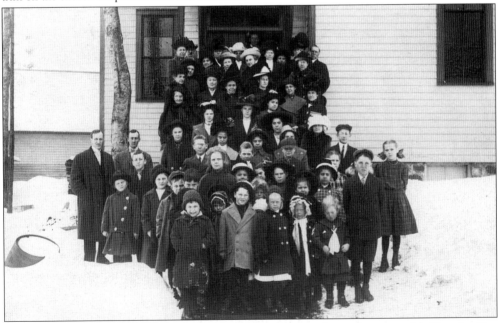

The congregation gathered on the church steps must have been made up of year-round resident families, as the card is postmarked April 4, 1910. The Sunday school class is pictured in the front. The main entrance leads into a small vestibule. Directly behind is the Sunday school room, still equipped with its child-sized oak desks and chairs. An effort is under way to place the church on the National Register of Historic Places.

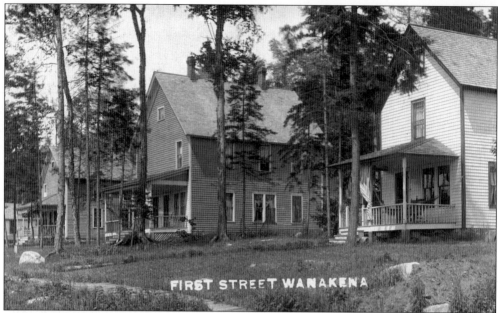

FIRST STREET WANAKENA

These company houses on First Street (above) and Sixth Street (below) are examples of the homes the Rich Lumber Company brought in sections by railroad from Pennsylvania and rebuilt in Wanakena. Nearly all the buildings in Granere were dismantled and moved. Train loads of hemlock lumber were also shipped in for new construction. Several hundred employees came with Rich, and these homes were occupied by mill workers with families. When Rich left Wanakena in 1912, the village was not abandoned like its predecessor, as summer tourism in the Cranberry region was at its height. Village homes were gradually sold to residents and to tourists for camps. Those on First Street are still standing, but the Sixth Street corner homes are gone. Rich also sold building lots on both sides of the flow, from Wanakena to the Narrows, over a mile downriver. These became popular sites for summer homes.

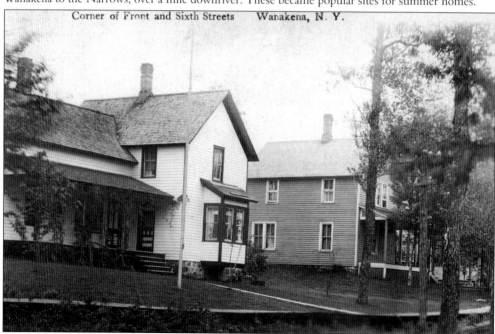

Corner of Front and Sixth Streets Wanakena, N. Y.

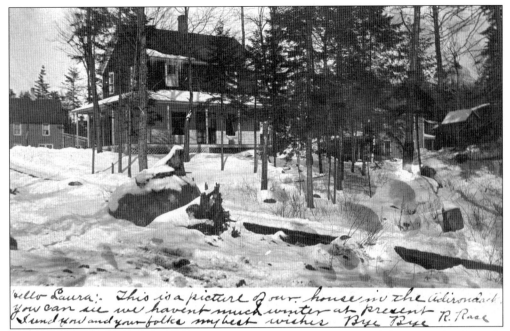

Hello Laura:. This is a picture of our house in the Adirondack. you can see we havent much winter at present I send you and your folks my best wishes Bye Bye R. Race

The message on this card, postmarked in February 1907 at Wanakena and mailed to Pennsylvania, reads, "This is a picture of our house in the Adirondacks. You can see we haven't much winter at present. R. Race." This large home on Third Street belonged to Andrew E. Race, manager of the Ford Brothers sawmill. It is still used as a summer home, with the wraparound porch enclosed and screened.

In this 1910-postmarked card, taken next to the depot on Front Street, they do seem to have enough winter at present. The message notes, "When you get warm look at this picture." The writer also asks, "Keep all the postals I send you," a reminder of the popularity of postcards in the early 1900s, with up to a billion cards sent each year. Many more were also bought by collectors, or as souvenirs, and never mailed.

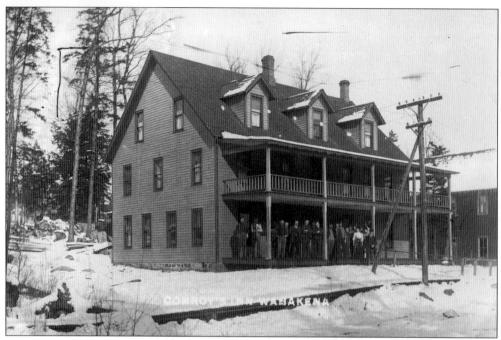

The Conroy family operated Conroy's Hotel, a large boardinghouse on the corner of Front and Third Streets. It is shown *c.* 1910 in the upper card. During the Rich Lumber Company's time, the hotel catered to single mill workers and area loggers. After the company left Wanakena, Conroy's continued as a tourist inn. After the original hotel burned, it was rebuilt as Riverside Inn. When this too burned, it was never rebuilt. The lower card, showing the office at Conroy's, is postmarked October 1923. It features a 12-point trophy buck over the fireplace, as well as a glass counter case filled with a variety of tobacco products. The message reads, "Went on the trail where we could see Cat Mt. and Little Round Top this morning. Are going to make the trip later. Tonight the guests from the Hotel were given a shore dinner. Wish we could stay here a month."

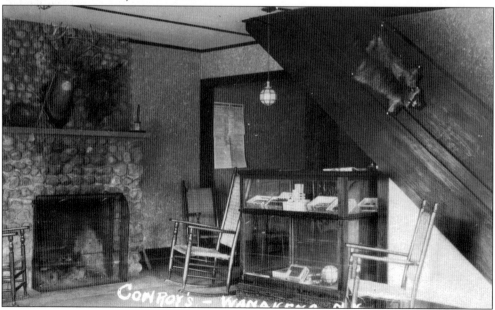

In 1902, the Rich Lumber Company built Wanakena's first school at the far western edge of the village, off Sixth Street. The large three-room structure taught primary, middle, and junior high subjects, with more than 100 pupils in attendance. This school burned *c.* 1917.

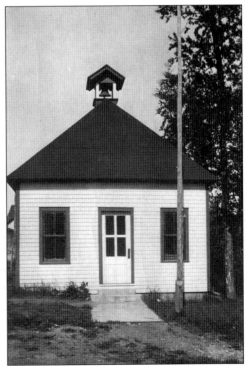

By 1917, the student population was so small that the former town jail at the end of Second Street was remodeled and used as a one-room schoolhouse. Seen here in 1920, it accommodated grades one through eight. This second school burned in 1926 and was rebuilt on the next lot north, now a private home.

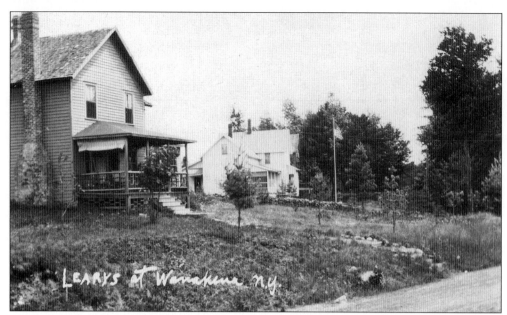

Leary's at Wanakena N.Y.

The Leary family moved to Wanakena in 1914 and started a hotel in a vacant house at the corner of Front and Sixth Streets. The hotel was run by sisters Bessie and Belle Leary. Brother Art Leary guided fisherman and hunters. The old hotel is now operated as a bed-and-breakfast known as Landmark Lodge. It bears little resemblance to this 1922-postmarked card, due to an attractive rustic remodeling and to the surrounding trees having had 80 years to reach maturity.

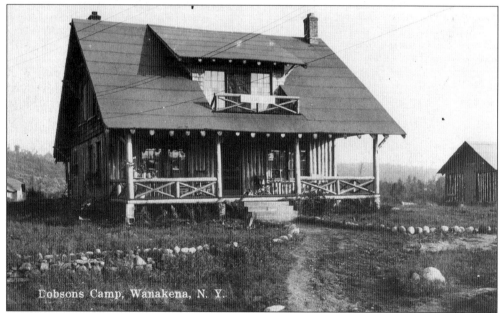

Dobsons Camp, Wanakena, N. Y.

Bert Dobson, a well-known guide, was the proprietor of Camp Watakalo, at High Falls on the upper Oswegatchie River. He also maintained this camp at Wanakena, located on the south shore on a knoll west of the mill complex. The stockade log construction duplicated the style of the main buildings at High Falls. Although this was Dobson's home, it also boarded guests traveling to and from High Falls. The handsome building is long gone.

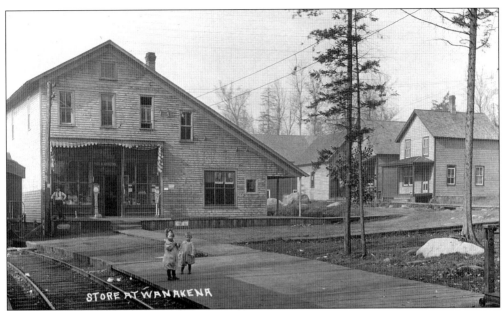

The upper card of the Rich and Andrews general store was taken from the depot, facing the store's main east entrance, with the shoe-repair shop and meat market across Front Street. The lower card looks south from the church and also pictures the reading room and depot. The store's first floor offered cookies, crackers, sugar, cereals, cheeses, butter, tea, coffee, drugs, fabrics, housewares, sporting goods, stationery, and shoes from ladies' button-ups to loggers' boots. The top floor displayed clothing and bedding. The basement held barrels of staples such as salted meats, pickles, olives, and molasses. The store also sold wagons, sleighs, harnesses, stoves, plumbing, tools, coal, ice, hay, and feed. Catalog ordering and traveling salesmen's wares added even more variety. The general store operated for years after the Rich Lumber Company left the area but was demolished in the 1950s. A grassy park and gazebo now mark the site, courtesy of the current general store's owner.

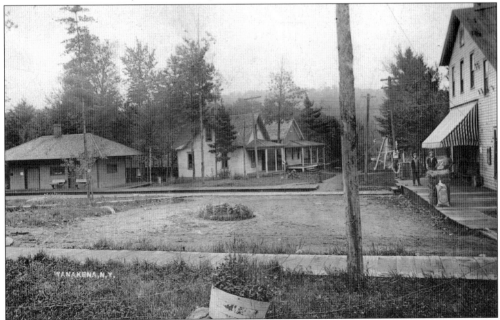

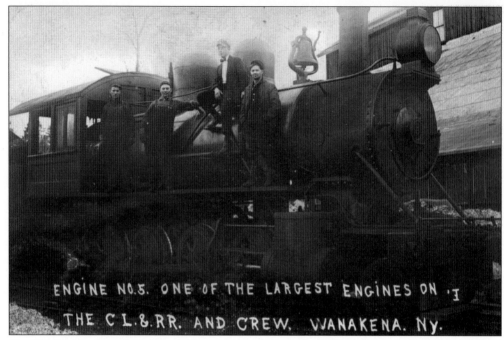

ENGINE NO.5. ONE OF THE LARGEST ENGINES ON
THE C L.&.RR. AND CREW. WANAKENA. NY.

The Rich Lumber Company needed a connecting line to a major railroad. The Cranberry Lake Railroad was chartered in 1902 as a common carrier to lay rail from Wanakena to the Carthage & Adirondack station in Benson Mines, six miles northwest. In 1905, the Rich Lumber Company purchased a new 51-ton rod locomotive for its captive railroad at $9,000. It is pictured in the card above, next to the machine shop at the western entrance to the village. No. 5 freighted lumber and other mill products to Benson Mines. From there, it moved supplies to Wanakena. It also pulled the passenger, mail, and baggage coaches on its two daily runs. Between 18,000 and 21,000 passengers were carried annually—proof that Wanakena had become a new gateway to the Cranberry Lake region. The card below shows the engine, coal car, and coaches parked on the siding next to the general store and depot. The locomotive has backed from Benson Mines, which had no turntable.

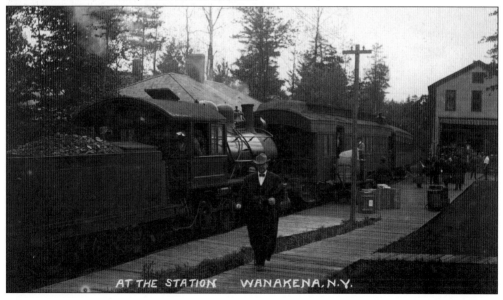

AT THE STATION WANAKENA, N.Y.

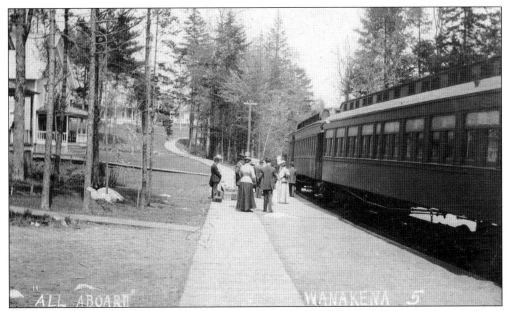

This 1910-postmarked card of the Cranberry Lake Railroad passenger coaches off Front Street was sent to Brooklyn and notes, "We expect to leave here Tuesday afternoon, and will take a sleeper to New York, arriving early Wednesday morning. We will be there for breakfast with you about 9:00; better have something extra as we have developed hearty appetites for breakfast." One of the railroad's two coaches was a combination smoking and baggage car.

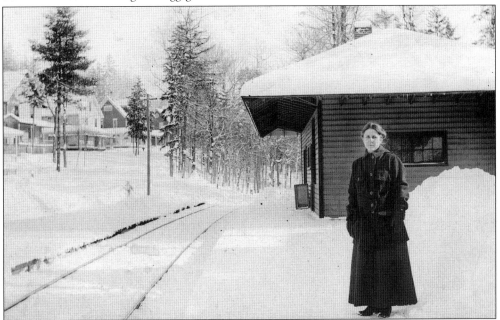

This winter scene of the depot features this message on the back, "Miss Moss my Sunday school teacher." The Cranberry Lake Railroad continued in operation until 1914. By then, the Grasse River Railroad to Cranberry village had become the region's main link to the big cities. The Cranberry Lake Railroad bed was made into an auto road in 1917. The depot was skidded across the ice to the South Shore Road, where it is now part of a private home.

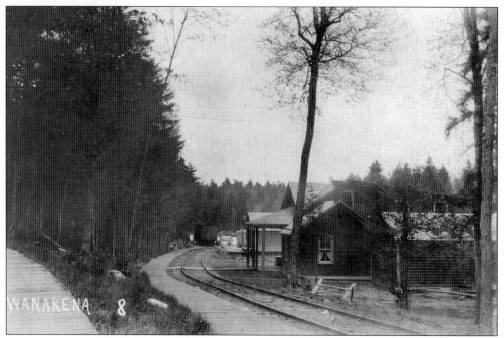

This *c.* 1910 card looks east from the depot to the boat landing and loading docks on the river. This was the end of the Cranberry Lake Railroad line in Wanakena village. A boxcar can be seen at the landing. The building in the foreground is the Boardwalk restaurant.

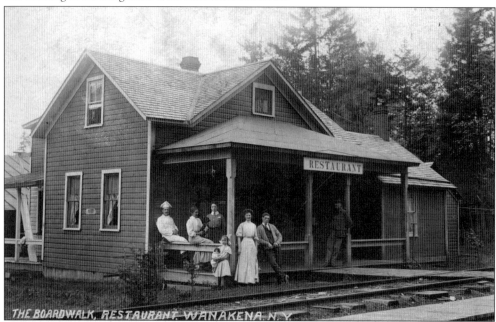

The Boardwalk (also known as Cora's Place and the Morrow Café) was the only public restaurant in the village. The hotels had their own dining rooms for guests. Although it was located just south of the tracks, slow-moving trains here probably did not rattle the silverware or deafen patrons. The people on the porch are owner Cora Morrow and staff. Her cook is to the far left. Only a small stone foundation is now left at the Boardwalk site.

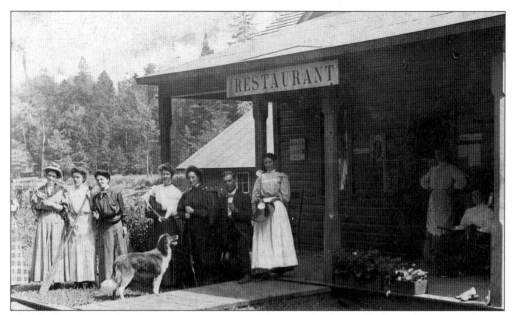

This card, postmarked August 1908, states, "We are having a lovely time. This is our crowd, taken in front of Cora's restaurant. Very pretty place and people." A close look at the lineup of women reveals four armed with rifles, cartridge belts, and knives and carrying pack baskets. One is holding a canoe paddle, and another is strumming a guitar. The sole male in the group, rather grim-looking, may have had his hands full with this "crowd."

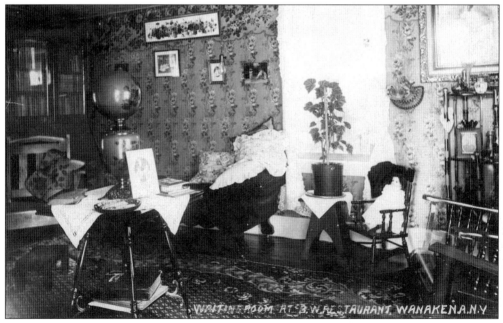

The waiting room at the Boardwalk, seen in this 1910-postmarked card, was charmingly furnished in busy Victorian style. Floral carpeting is matched with floral pattern wallpaper. The walls are hung with framed prints of children. A large *Gone with the Wind* lamp occupies the center of the room. Behind it is a pillowed fainting couch. The small rocker next to the potted plant holds a child's doll, perhaps belonging to the little girl seen in the card opposite.

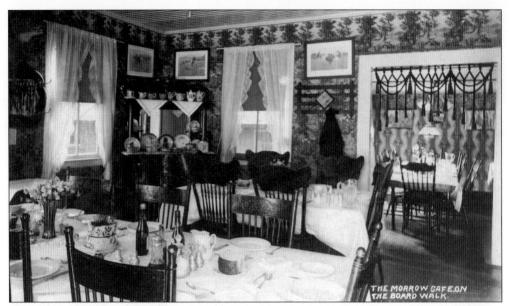

This card shows the two small dining rooms at the Boardwalk. Victorian styling continues, with intricate wallpaper, fine lace curtains, tasseled ropes in the doorway, and pressed-wood chairs. A mirrored corner buffet displays china, and Frederic Remington prints hang on the walls. The owner's personal decorative touch and service helped distinguish her café from the spare dining halls at the hotels. Like them, however, no liquor could be served here, per the Rich Lumber Company's early attempt at prohibition.

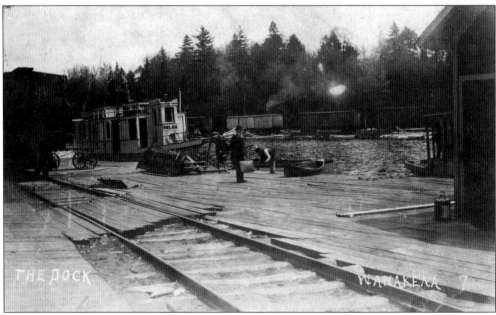

Just east of the Boardwalk were the boat landing and docks, seen in this 1908-postmarked card. Passengers, baggage, mail, and supplies bound for destinations on Cranberry Lake boarded the steamboats here. The *Helen* is seen at the dock. The lengthy message details preparations for a football game with a neighboring town. The writer cautions, "Bring fellows of Roy Young's size as our fellows won't play any others. We'll pay for dinner for ten."

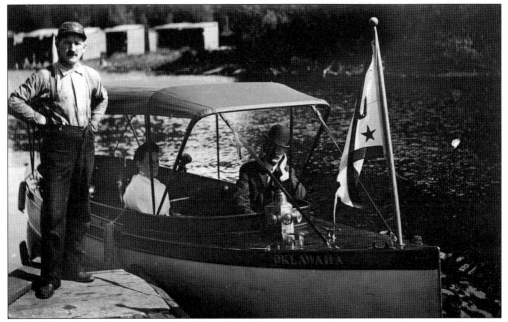

The tour boat *Oklawaha,* a large motor launch, was berthed at the village boathouses. It is seen at the landing, preparing to board passengers for an excursion. The man's bowler hat and starched shirt and the woman's leg-of-mutton sleeve blouse look uncomfortable. Doubtlessly, they would have considered more casual dress to be unsuitable. The *Oklawaha* is believed to have been owned by Patrick Ryan or George Schlieder, operators of the Ryan & Schlieder Lath Mill.

The Rich Lumber Company built the *Comet c.* 1910 for the yearly boat races on Cranberry. For several years, it was the fastest boat on the lake. Its 40-horsepower, four-cylinder gas engine and sleek lines helped it fly along at an impressive 40 miles per hour. A moveable, floating boathouse for the *Comet* was built on empty wood barrels, with a canvas-covered frame. After the Rich Lumber Company left Wanakena, the *Comet* was sold to the owners of the *Helen.*

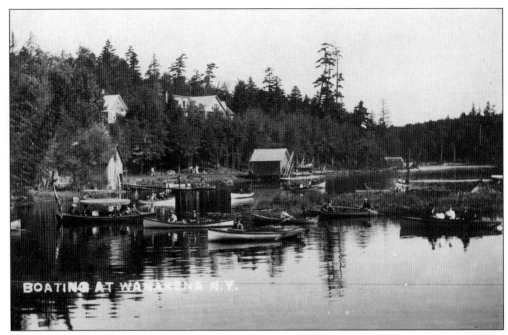

This scene of a gathering of small craft—motorboats, canoes, and guide boats—was taken looking downriver from the footbridge, with the village dock and Hotel Wanakena in the background. Due to its sheltered harbor, a large fleet of boats was moored at Wanakena. These may be preparing to head out to Cranberry Lake, for the races and other festivities at the annual regatta and field day.

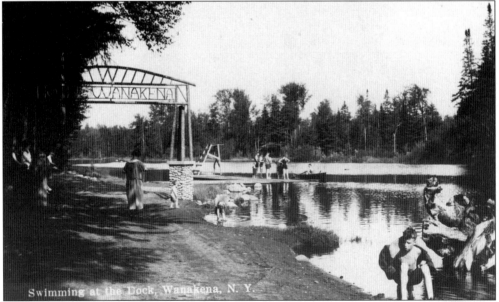

By the time of this 1920s card, Wanakena had changed from a bustling mill town to a quiet village at the end of a winding road. Still, many tourists continued to spend summers at the hotels or private camps. Sportsmen arrived in spring and fall. The Hotel Wanakena maintained the landing area after the tracks were removed, as a swimming beach for guests and their children. The village still provides a public beach and small dock here.

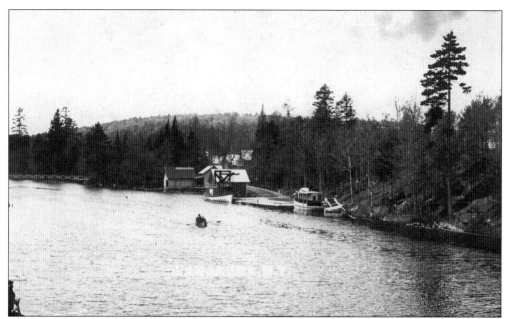

These two *c.* 1910 views of the landing and village boathouses show the drastic effects of varying water-level regulation on Cranberry Lake, basically a reservoir. For many years after the dam was completed in 1867, water levels were maintained to satisfy downriver mills and power interests, with little attention paid to the needs of lakeshore owners for a navigable waterway. Flooding in spring was followed by low water in August and September, and Wanakena was often left high and dry. Access to the main lake might involve walking along the shore, rowing into deeper water, transferring to a small motorboat, and finally switching to one of the larger steamboats or motor launches at the junction with Dead Creek Flow. Not until the 1950s was general agreement reached to keep a reasonable lake level and to limit summer drawdowns.

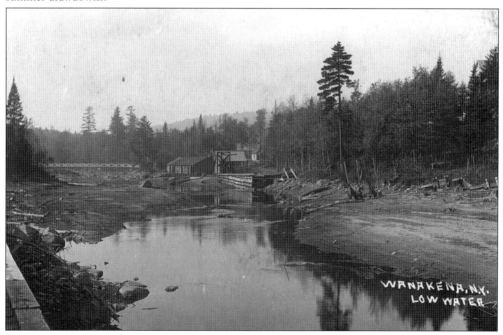

The four Wanakena cards on this page and the next are all examples of the custom-made real photo postcards created by early photographers. Usually produced in small batches, some were kept as a memento of an important event, such as this card postmarked January 1911. It was evidently taken the previous summer of a wedding party. The message ends, "This will recall the good time we all had the day the knot was tied."

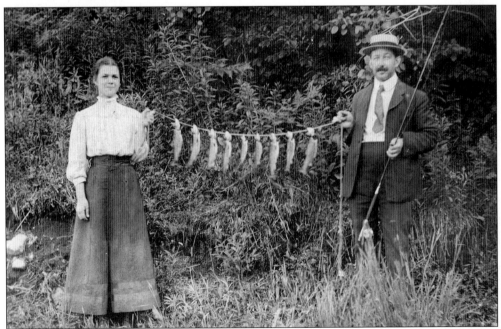

Another reason to send a real photo postcard was to show friends and family back home what a fun time the tourist was having. This July 1907 card, sent to Edwards, is marked "Ida Jacot and Uncle" on the back. The young lady and her uncle proudly display their small string of trout.

86

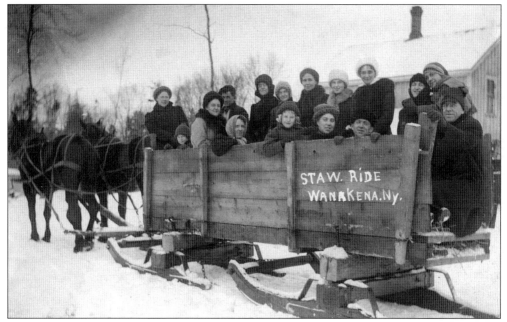

This scene of Wanakena residents on a "straw ride" may have been arranged by the Rich Lumber Company to liven the long Adirondack winter. The logging two-sled and crib were certainly provided by the company. Rich took a paternal interest in the physical, mental, spiritual, and social welfare of its workers and their families. Readers interested in the history of similar company towns in the North Woods will enjoy Peter C. Welsh's *Jacks, Jobbers, and Kings.*

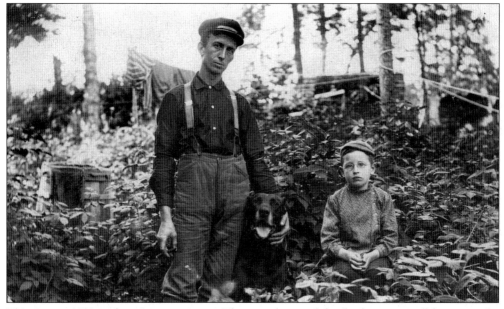

This August 1905 card carries no message. The man, boy, and family dog were well known to the recipient. From his dress, the man was probably a Wanakena mill worker. The card may have been sent to the hometown he left to find employment. Most Rich Lumber Company workers migrated with the company—from Gardeau to Granere, Pennsylvania, to Wanakena, and finally Manchester, Vermont—covering a period from 1886 to 1925.

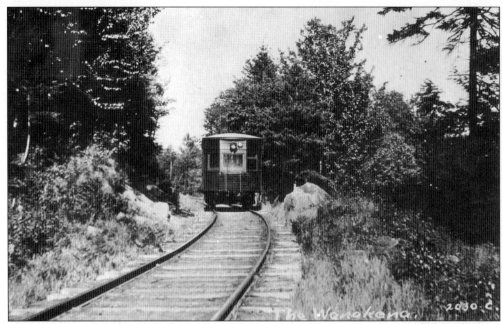

An enclosed gas speeder car is seen in this July 1913 card. Speeder cars were used to economize rail travel between Wanakena and Benson Mines and ran until 1917. The view is at Shannon's Bend, a sharp curve one mile north of Wanakena. Squealing wheels here signaled the train's arrival at the village. The message notes, "The speeder is pretty good looking, but awfully noisy. Only excitement around—go to meet it every night."

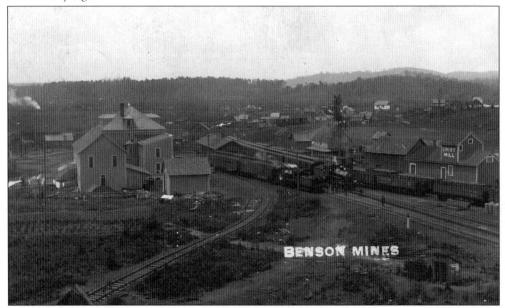

This 1907 view from the top of a conveyor at Benson Mines shows the New York Central train to the right, meeting the Wanakena engine and its two coaches. The building to the left is the Ellsworth Hotel, very popular with parched Wanakenians. Owner Sylvester "Sam" Spain was famous for his Parker House Rolls, for his own brand of Spain's Pride whiskey, and for maintaining a level of civility unmatched by the dozen other Benson Mines saloons. The Ellsworth burned in 1925.

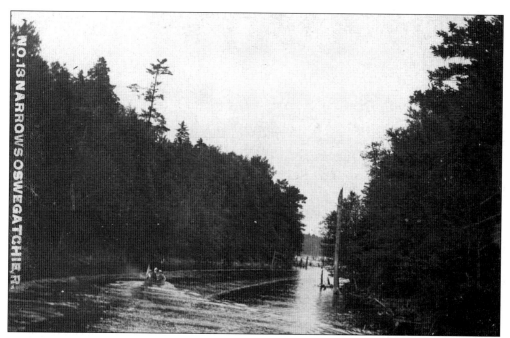

By the time the Rich Lumber Company created Wanakena village, the Narrows of the Oswegatchie (located a mile downriver) were already well known. Before Cranberry Lake was flooded, the river must have passed through a small high-walled canyon here. After the dam, it became a picturesque bottleneck on Cranberry's Inlet Flow. In this 1910 card, a small motorboat is seen passing through the Narrows, in the wake of a larger steamer.

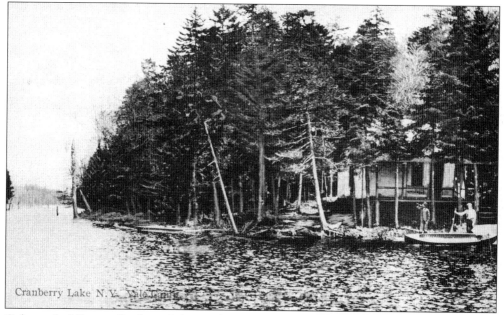

Only one building on Cranberry Lake stood near the future site of Wanakena—a small cabin on the southwest bank of the Narrows. Seen here *c.* 1907, the cabin was built in the 1890s by a group of Yale professors as a summer retreat. The professors never returned after logging began. Fallen trees have nearly demolished the old cabin, but it has been replaced by a new camp on the inside of Yale Point.

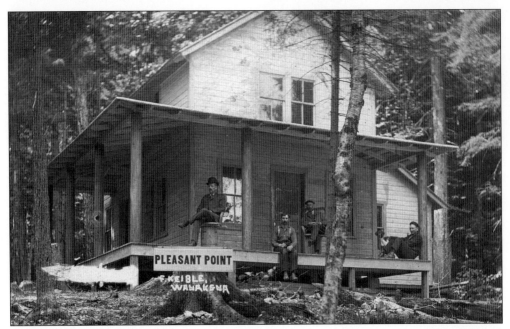

Francis Keible, operator of two Wanakena-vicinity camps, is pictured in the center of this 1909 card, taken at his cottage on Pleasant Point. Located on the northeast shore of the Narrows, this cottage had a fine view down the flow. It boarded guests who did not want to "rough it." It is unknown whether his cottage burned or was demolished and replaced by the larger home that now stands on Pleasant Point.

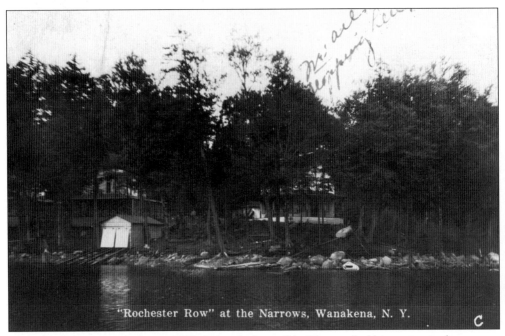

"Rochester Row" at the Narrows, Wanakena, N. Y.

When this card was sent in August 1925, the north shore of the Narrows had become a popular summer colony. Camps were built mainly by residents of Rochester—hence the name Rochester Row. Several of these cottages still stand, including the two pictured here. The one to the right occupies Pleasant Point, the site of Keible's old camp.

Six
MILLING AND LOGGING
AT WANAKENA

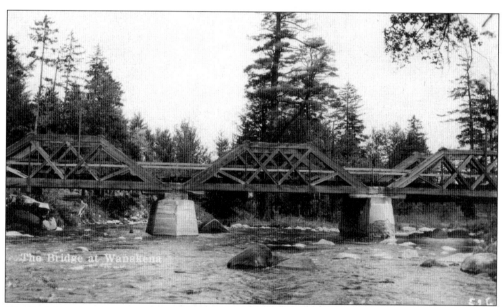

The Rich Lumber Company built this lattice railroad bridge to its mills, upstream of the worker's footbridge. The company brought years of experience in railroad logging to Wanakena. Within a year of 1902, the company had built not only its common carrier to Benson Mines but also a logging line south from this bridge to the Plains area, nine miles by rail from Wanakena. Another railroad branch was built east from the mills to Dead Creek Flow, about two and a half miles. Still another railroad branched off the main line a mile north of the village and weaved for about five miles on the northern boundary of company property. Several additional short spurs made up the company railroad logging system.

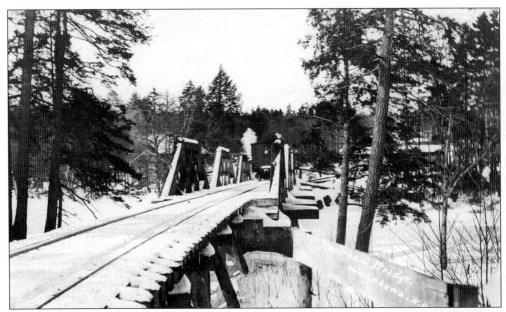

This *c.* 1908 winter scene was taken from the south shore, with a train headed to Wanakena village. The Rich Lumber Company's short stay in the Adirondacks was made possible by its intensive railroad logging. The 16,000-acre tract was stripped in about eight years. In 1912, the company moved to a new operation in Manchester, Vermont, and removed the rails on its logging lines. An iron car bridge now crosses the river on the site of the old railroad bridge.

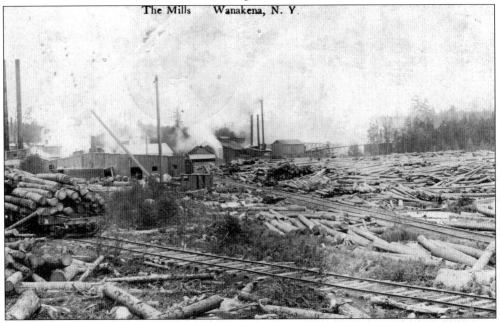

The Rich Lumber Company believed in full utilization of its timber resources and built a variety of mills at Wanakena, all operated by other companies. The mills were lined up along the north edge of the millpond, accessible to the logging railroad as it swung in from the southwest. The long building to the left is the veneer mill. Others included the world's largest buggy whip mill and a shoe-last factory, maker of the "fairy shoe form."

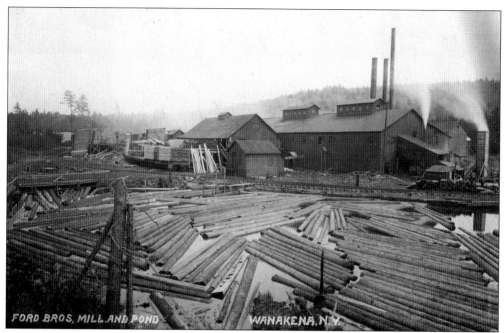

FORD BROS, MILL AND POND WANAKENA, N.Y.

In 1903, Royal and Hemen Ford built a large steam sawmill at the eastern edge of the millpond, under contract to the Rich Lumber Company. It operated until 1910. The mill had two bandsaw head rigs and was capable of sawing up to 100,000 board feet of softwoods per day. The upper card shows an overview of the pond. In the center is a small building used to load the finished product onto railroad cars, with the sawmill behind it. Logs entered the mill via the chute to the right, where a hooked chain conveyor pulled them from the pond. They were scaled and then rolled onto a carriage inside the mill. The sawyer moved log and carriage to a bandsaw. As boards were cut, a steam "kicker" kept the carriage rotating, until the log was entirely sawn to the desired dimensions. The lower card shows the lumber docks, where the product was sorted and stacked to air dry.

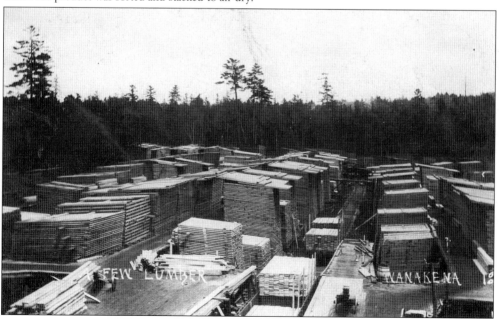

FEW LUMBER WANAKENA

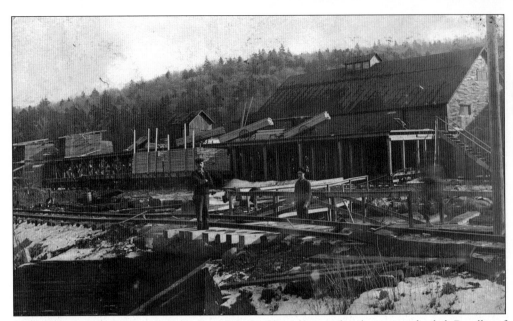

This October 1908 card is a close-up view of the building where railroad cars were loaded. Bundles of spruce and pine lumber were moved around the yard by hand, using one-axle dollies. Several of these are positioned over the car being loaded. The message notes, "Duncan McDonald and myself in Bridge building one year ago." McDonald was a logging jobber for the Rich Lumber Company. The bridge was over Skate Creek, dammed to create the millpond.

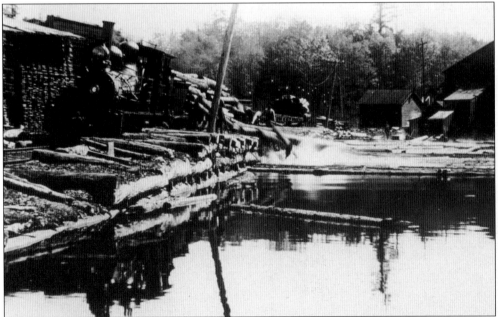

The millpond was an important part of the sawmill's operation. It allowed the sorting of logs for the day's run and washed off dirt. The railroad was slanted toward the edge of the pond. Loggers released side chains on the cars, and the logs were rolled off into the water. The Ford Brothers sawmill also heated its log pond, keeping it open all winter. Exhaust from the mill's sawdust-fired steam engines was piped into the pond.

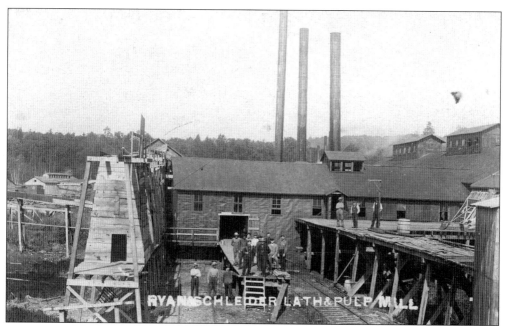

These *c.* 1907 cards are views of the Ryan & Schlieder Lath and Pulp Mill, operated in connection with the Ford sawmill. Owners Patrick Ryan and George Schlieder advertised as "Manufacturers in Spruce, Pine and Hemlock Lath; Sulphite Chips and Box Lumber." This mill received slabs and edgings from the sawmill and produced laths—strips of wood that were nailed to the walls and ceilings of buildings to support applications of wet plaster. The lower card pictures men standing in front of what appears at first to be logs but are actually bundles of lath. The rest of the waste wood was rossed (debarked) and fed through a chipper. The chips were sent to the sulphite paper mill at Newton Falls. The modern chipping industry still uses the same techniques pioneered by Ryan & Schlieder.

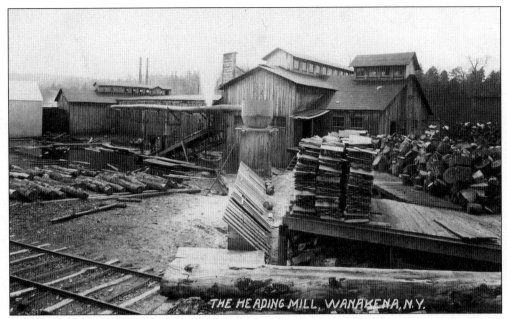

A large mill for the production of barrel heads was located west along the pond from the sawmill buildings. The heading mill cut up hardwood logs, assembled them into barrel heads, and shipped these to cooperage manufacturers. The mill was owned by Henry Venters and was the last mill to close in Wanakena (1912).

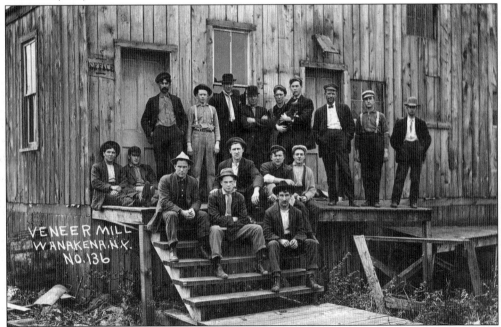

Setter Brothers, a western New York firm, built a small veneer mill in 1902 at the far western edge of the mill complex. A group of workers is pictured in front of the office. Setter Brothers manufactured plywood and fine veneer for furniture. Its Wanakena mill operated until 1911 and used only high-grade yellow birch logs. The mill cut the veneers on a rotary lathe and then sent them to the company's manufacturing center in Cattaraugus.

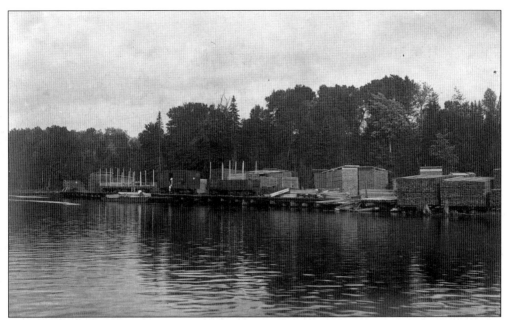

This is a view of Bissell's Dock, located on the south shore across from the village dock. The Bissells built the first sawmill at Cranberry village in 1904, long before the Grasse River Railroad operated. The brothers towed lumber from their mill to Wanakena by barge, seen here at the dock. It was loaded onto railroad cars and moved to market via the Rich Lumber Company's Cranberry Lake Railroad. Forest products from other operations on the lake were also shipped here.

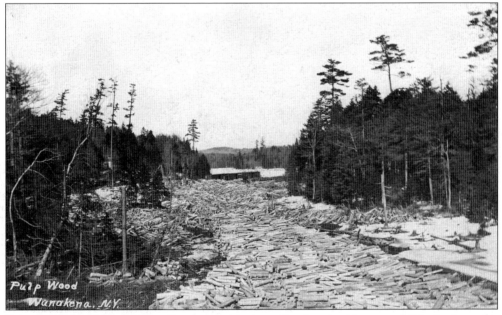

Taken on the Dead Creek Flow railroad spur, this scene of a winter banking ground full of pulpwood is a bit unusual. The Rich Lumber Company and its jobbers cut very little pulpwood on company property. Small spruce could be used to make pulp for papermaking, but the Rich Lumber Company was interested in the larger spruce, white pine, and hemlock that could be sawn into lumber for home building and other construction.

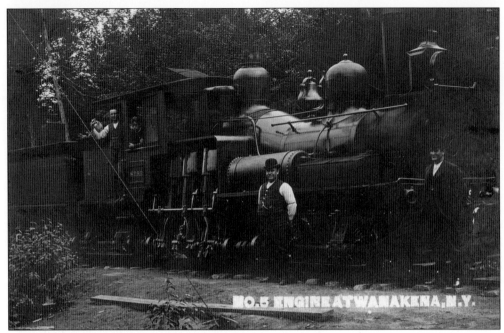

The Rich Lumber Company used Shay locomotives on its logging railroads. Shays used gears to drive the wheels, instead of conventional side rods. As seen in the upper card, postmarked 1906, a Shay engine had three vertical cylinders on the right side of its boiler and a horizontal drive shaft along the outside face of the wheels. Shays could pull heavier loads over twisting track and steeper grades. Pictured is No. 4, with engineer Eugene Madison in the center. The Rich Lumber Company brought Shays No. 2 and No. 4 (both 50 tons) from its operation in Pennsylvania. The lower card shows the wreck of the No. 2 Shay in 1908. It was backing a string of log cars to High Falls when low water caused the boiler to explode. A fireman was killed, as well as a jewelry salesman traveling between lumber camps. The salesman was struck as the smoke box door (missing, at center) blew out. No. 2 was rebuilt and renumbered as No. 6.

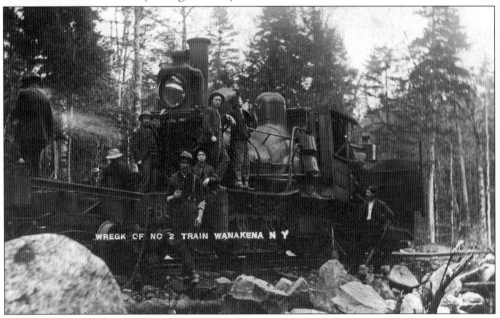

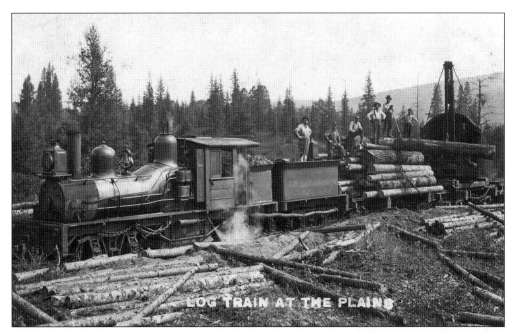

In addition to its two Shays, the Rich Lumber Company's Wanakena operation also included a Barnhart steam loader, a snowplow, water tank cars and fire hose, and 27 log cars, all equipped with air brakes. Although the company contracted out all logging, its own crews operated the Barnharts, which sat on the log cars and moved along on top of them. Both of these cards date from *c.* 1908. The upper view shows Shay No. 4 beginning a loading operation at the Plains, at the southern end of the High Falls line. The Plains are a mile-long expanse of grasses and shrubs, drained by Glasby Creek. In this area, sandy soils, spring floods, and frost pocket characteristics have discouraged the growth of trees. As seen in the lower card, the Rich Lumber Company found it an ideal skidway (an area to stockpile logs for later loading on cars).

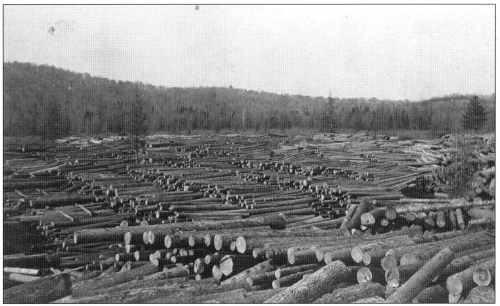

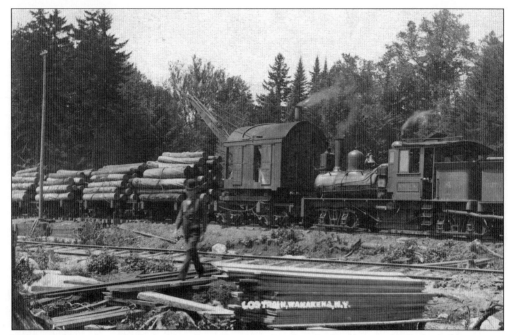

This card shows the end of a day's work, as Shay No. 4 pushes the Barnhart and fully loaded log cars to the Ford Brothers sawmill at Wanakena. One of the Rich Lumber Company's skilled Barnhart operators could load 20 cars per day, with 20 to 30 logs in each car. The record for one day was about 800 logs.

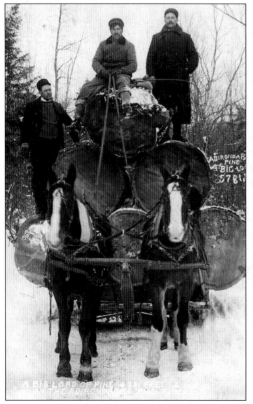

This load of Adirondack pine was cut *c.* 1905 in the Skate Creek area, just south of Wanakena village. The sled of six white pine logs scaled 5,781 board feet. The sender of the card, writing in 1911 to his sister in Gouverneur, writes, "Send my trunk and good suit of clothes and other things like what a fellow would want to dress up. I want to get out among the people and get acquainted."

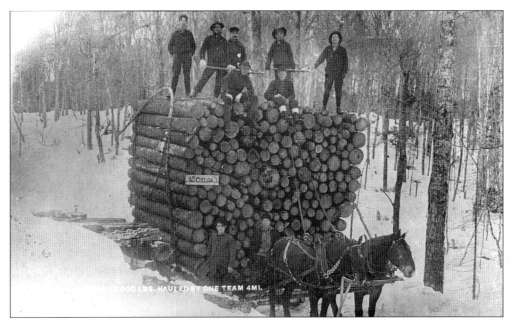

Another impressive sled of red spruce sawlogs is headed to the Dead Creek Flow railroad spur via an iced winter road. This card is captioned, "15 cord load, weight 65,000 lbs., hauled by one team 4 miles." Why the Rich Lumber Company did not make more use of these iced roads (avoiding expensive railroad building) is a mystery. Experienced loggers could chop 60 logs in a 14-hour day and were paid between $25 and $40 per month, depending on ability.

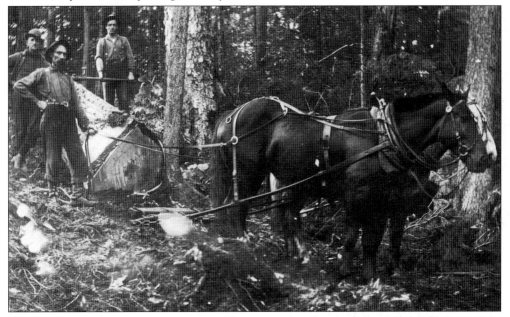

This card, postmarked in 1910 at Wanakena, shows a single yellow birch log being skidded out of the woods, on its way to the veneer mill. Two types of horses were used in logging operations. The heaviest horses were used to haul loaded sleds on main roads, as seen in the previous card. Small, well-trained, and agile horses were needed to snake individual logs out on woods trails. They are sometimes still used for this work.

101

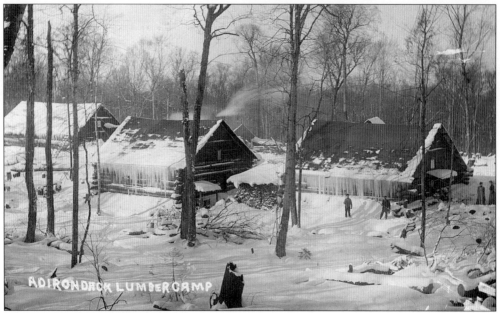

The Rich Lumber Company brought Swedish and Italian logging crews from Pennsylvania and hired local French Canadians. All built their own camps, as seen in this card, postmarked in 1909 at Wanakena. Jobbers ran the camps but were coordinated by a Rich Lumber woods boss. Large camps were also located west and north of Wanakena village to house mill workers. All were subject to company dry laws, except for the Italian camps, which were allowed to possess beer but not to sell it.

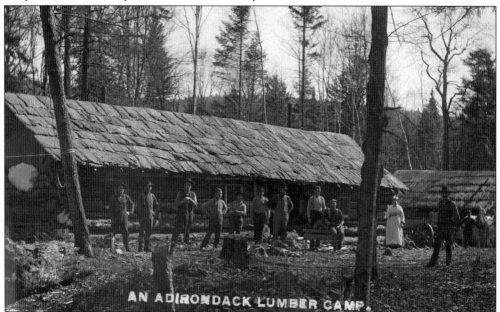

This *c.* 1908 card shows jobber Jim Weston's lumber camp at Bassout Pond, northeast of High Falls. The cook is female; women were often employed as cooks in the hope they would have a civilizing influence. The job was demanding—from serving 30 to 40 men breakfast at 4 a.m. to serving dinner at 7 p.m. Furthermore, women were held to the same rule as male cooks: the loggers had to be well fed or they went elsewhere.

Seven

WANAKENA TO INLET AND HIGH FALLS

FROM THE R.R. BRIDGE, WANAKENA, N.Y. LOOKING UP THE RIVER

The East Branch of the Oswegatchie River, the main feeder of Cranberry Lake, stretches above Wanakena for over 20 navigable miles. The first two miles are marked by heavy rapids. Above Inlet landing, the mostly flat, coffee-brown river meanders through swamps, marsh, and conifer forests. This c. 1910 view looks upstream from the railroad bridge in Wanakena. On the right (north) side the Rapids Trail is still a pleasant, scenic walk between Wanakena and Inlet. Although the card is not dated, it shows a summer scene of low water. In spring, most of the rocks and islands would be covered. The river's name is derived from the Mohawk word *oswagahonsti,* meaning "black river."

This card shows spring runoff on the river, midway between Wanakena and Inlet. The view looks up Little Falls, the most popular early trout fishing spot in the area. Beginning in the 1860s, sportsmen made the upper Oswegatchie famous, but guides carried their boats around this stretch of whitewater. Now, modern canoeists and kayakers run the challenging series of Class III and IV rapids.

This 1905 view may have been taken to memorialize a friendship between sport and guide. As a 1915 Cranberry brochure lyrically described, "our good friends, the guides, are friendly, thoughtful, hardy, sincere, and efficient. . . . They will render honest and painstaking service. . . . It is a rare privilege to know these men of the woods." With his .22 rifle, the gentleman may have been hunting small game.

Two miles above Wanakena, the old Albany Road crossed the Oswegatchie at a shallow ford known as Inlet. The Albany Road was begun during the War of 1812. It followed the route of a Native American trail taken during the Revolutionary War by loyalist Sir John Johnston, from the Mohawk Valley to Canada. Construction on the road, with a northern end near Russell, was never completed in its entirety. The upper card of the Inlet House grounds shows the Albany Road coming in from Benson Mines to the northwest. This now leads in three miles to modern state Route 3. The lower card, postmarked in 1906 at Wanakena, looks upriver from an early bridge at Inlet. The Albany Road from here south was only a rough trail, maintained by sportsmen. A newer suspension footbridge still crosses the river to several private camps. Inlet and the lands south are now part of the Five Ponds Wilderness Area.

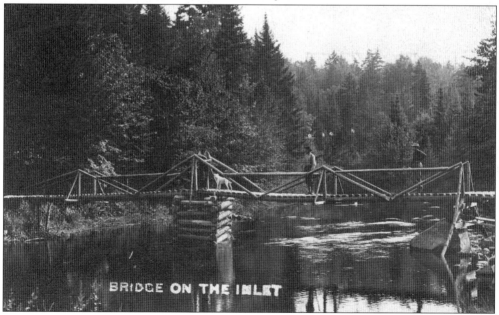

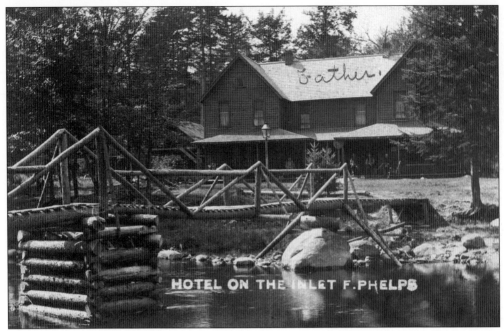

The original hotel at Inlet, located on the north shore of the river, was built by George Sternberg in 1884. It catered to sportsmen and was the headquarters for river guides. After the hotel burned, it was rebuilt, as seen in this *c.* 1905 card. In 1901, Rich Lumber Company superintendent Leonard Willson stayed at Inlet House to select timberlands for purchase, choose a site for the new mill town, and supervise the initial construction at Wanakena.

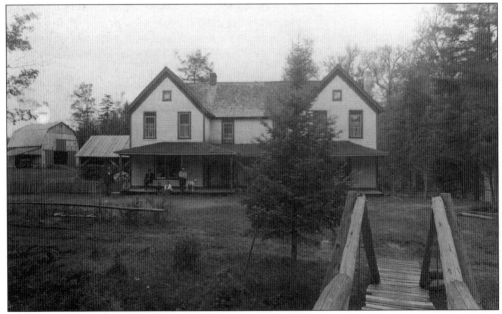

Access to Inlet House continued by stagecoach from Benson Mines, but the Cranberry Lake Railroad to Wanakena brought many sportsmen and tourists willing to walk the two miles to Inlet over the Rapids Trail. Cabins were added to meet the demand, as well as vegetable gardens, a dairy herd, and icehouse. The hotel also rented boats and sold supplies to upriver travelers. This card is dated August 28, 1912.

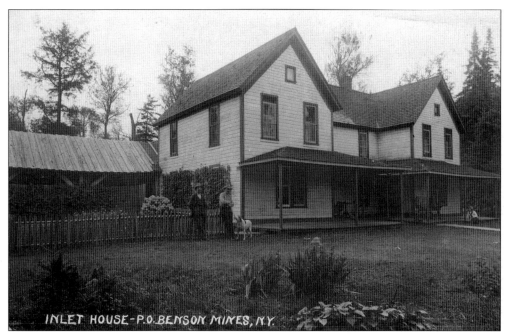

Inlet House was a private inholding on Rich Lumber Company lands. It was not subject to the company dry laws (which continued in force after the Rich Lumber Company left the area), and a licensed bar was located in the hotel. Loren and Mary Moore purchased the property in 1915. After a succession of owners, the state bought the 28-acre site in 1963 and demolished the buildings. Only a clearing with a picnic area and canoe launch now mark where Inlet House stood.

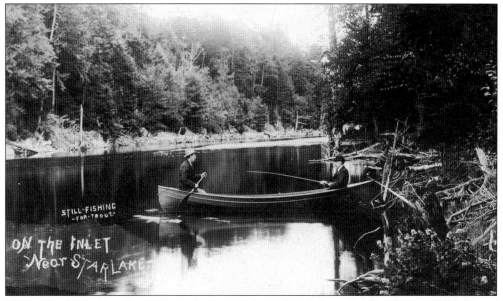

This *c.* 1910 card, titled "Still-Fishing for Trout," shows famed Oswegatchie guide Wilfred Morrison and a client on the river above Inlet House. The highlight of Morrison's career was his arrest and acquittal on charges of possessing illegal venison. Evidence at the Wanakena trial was inconclusive, but the proceedings were definitely merry. This story is best told in Herbert F. Keith's book of Wanakena's heyday, *Man of the Woods*.

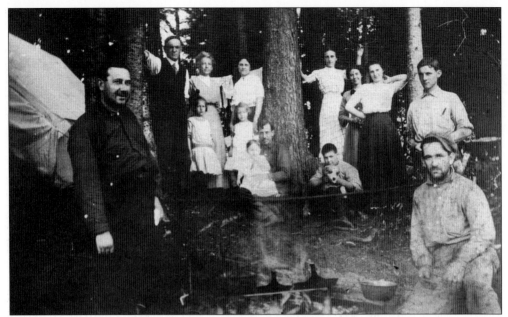

These cards are both marked on the back, "Wanakena NY First Week of August 1911—Sanford family on the Inlet." The typical family party on vacation included extended family members—parents, children, grandparents, aunts, uncles, and cousins. It is hard to imagine how they all enjoyed the summer while dressed in layers of starched clothing or how white shirts and long dresses were kept clean while camping. The family may have hired guides, like the men cooking a meal in the foreground of the upper card, or carrying pack baskets in the lower view. The demand for guides around Cranberry continued longer than in other parts of the Adirondacks. The region was remote, and the state was later in clearing, marking, and mapping trails for the general public.

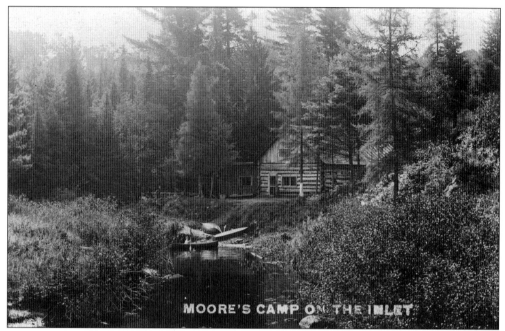

MOORE'S CAMP ON THE INLET

About 11 miles above Inlet are the Round Hill Rapids, one of a series of small rapids between Inlet and High Falls. Walter Moore's lumber camp was located here on the south side of the river, on a high flat knoll. Moore was a Rich Lumber Company jobber. The view dates from *c.* 1907. The rapids were named for the small round hill behind the buildings. The site is now only a clearing and camping ground.

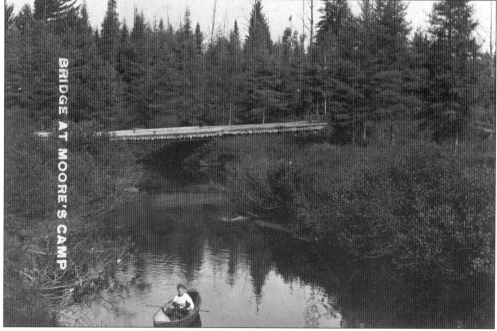

BRIDGE AT MOORE'S CAMP

Walter Moore constructed this footbridge to his logging camp at the head of Round Hill Rapids. A newer footbridge on the Five Ponds trail, built by the state, spans the river at this point. It leads to a chain of ponds and the virgin timber south of the St. Lawrence–Herkimer county line.

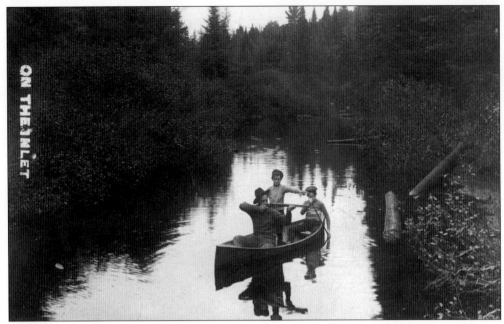

The boy standing in the center of the canoe is the same young fellow seen paddling in the previous cards at Moore's camp—perhaps accompanied now by his father and brother. He is pointing toward shore, although the target of the hunter's aim is not visible. Their canoe may have been a lightweight but sturdy Rushton, made in nearby Canton. These were favorites of the river guides.

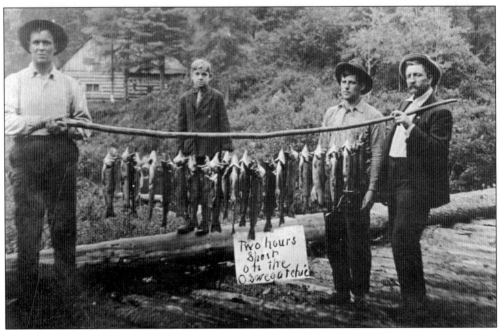

Pictured with Moore's camp in the background, this impressive string of brook trout was caught in "two hours sport on the Oswegatchie." Views like this were all too successful in bringing anglers to Cranberry Lake and the upper Oswegatchie River.

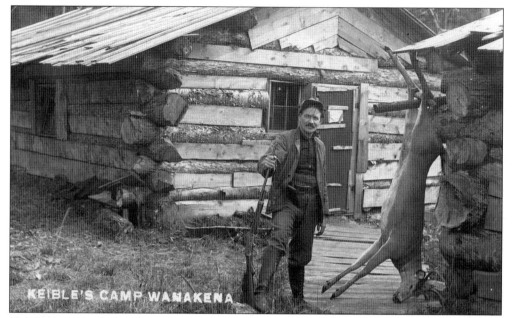

KEIBLE'S CAMP WANAKENA

This 1912-postmarked card, sent to Rochester, pictures Francis Keible at his second Wanakena-vicinity camp. The location is uncertain but is believed to have been near High Falls. Keible probably occupied one of the abandoned lumber camps in the area and appears well satisfied with the results of a successful hunt. A disgruntled (and lonely) sportsman thought otherwise and wrote, "The D-e-e-r-s are more scarce in the mountains than the D-e-a-r-s in Rochester."

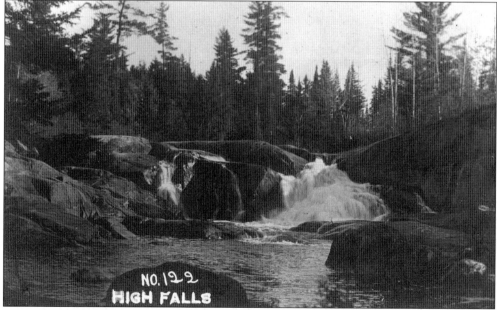

NO. 122
HIGH FALLS

High Falls, at 13 miles above Inlet, is only about 15 feet tall. Nevertheless, fishermen came from afar to catch the five-pound trout trying (unsuccessfully) to jump the falls. The river is canoeable for several miles above the falls, but now many beaver dams make this a challenge. In 1910, there was only one—Beaverdam, about three miles upriver. This dam, 300 feet long and 8 feet high, backed up a famous trout pond.

The original camps at High Falls, located on the east side, were built by the Rich Lumber Company and used as headquarters for its logging jobbers. By 1907, the company had turned the site and buildings over to guide Bert Dobson, who began operating a tourist and sportsmen's camp. Camp Watokalo is seen here in a card postmarked in 1909 at Wanakena. The main sleeping cabin is pictured with the falls in the background. About 40 guests could be accommodated.

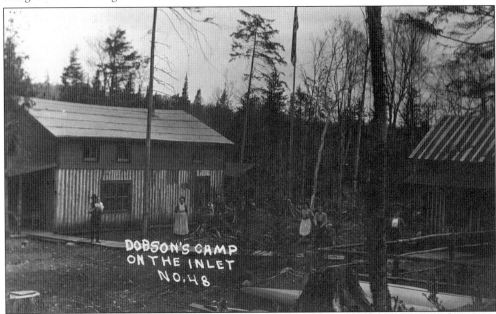

The building to the right is the kitchen cabin. Bert Dobson's wife, like those of other successful resort owners, was known as an excellent cook. Dobson advertised "rustic log cabins, comfortable rooms, good wholesome food, finest trout fishing and deer hunting to be found," all for $1.50 to $2.00 per day. He also noted that "some of the guests who have visited here are Irving Bachellor, Ernest Thompson Seton, and other authors and naturalists."

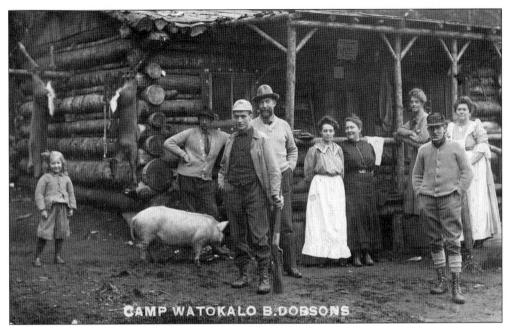

CAMP WATOKALO B.DOBSONS

In the upper card, Bert Dobson is pictured in the center, holding a Savage lever-action rifle. His aproned wife stands behind him. Guests returned yearly to hunt, fish, rest, read, write, and observe wildlife. Dobson may have advertised too well; the popularity of Camp Watokalo dismayed many who came for the site's isolation. The cutting of white pines around the camp also destroyed much of its early beauty. Dobson eventually left for another part of the Adirondacks, and guide Walter Gates operated the resort for a few years, as Postern Lodge. After the Rich Lumber Company left Wanakena, many people tried to buy the land around High Falls, but the company refused. In 1919, the state purchased the entire 16,000-acre parcel and razed the buildings at the falls. Now, High Falls is still popular with hikers and canoeists, and two state lean-tos are located here, one on each side of the river.

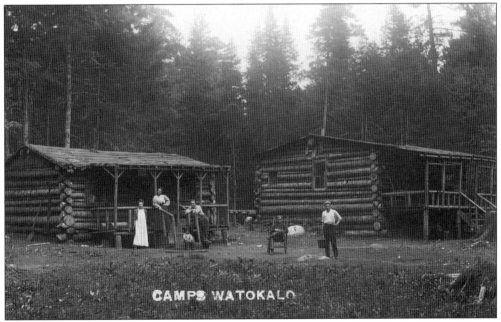

CAMPS WATOKALO

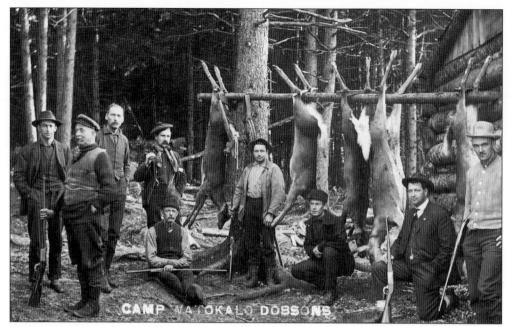

In this 1909-postmarked card, Bert Dobson stands to the far left of a successful hunting party. The message states, "Does this not make you want to come up hunting? We had 46 frogs legs and 12 fish for dinner." Dobson cut his own beeline trail from Wanakena due south to High Falls. The Dobson Trail continued in use as an unmarked path until July 1995, when it was obliterated by a microburst, a series of small tornadoes.

Bert Dobson also appealed to nature-loving tourists: "Those who like to hunt with a camera can find ample opportunity—on any summer evening, a short trip in a canoe will take the photographer to where the deer come down to drink, and so tame are these animals that he will have no difficulty in securing good pictures." To prove it, Dobson posed for this 1910-postmarked card, approaching a resting deer.

114

Eight

THE RANGER SCHOOL
AND FORESTRY
SUMMER CAMP

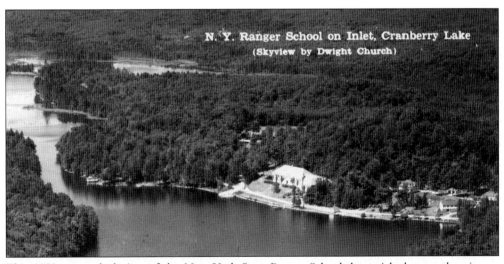

This 1950-postmarked view of the New York State Ranger School, by aerial photography pioneer Dwight Church, looks up the Narrows toward Wanakena, one and a half miles west. The idea for the school's origin is credited to J. Otto Hamele, chief millwright at the Ford sawmill. Hamele had seen the damage done by early lumbering methods and thought the nearby cut and burned lands might be used as an experiment station. In 1912, he convinced the Rich Lumber Company to donate 1,800 acres of land to the New York State College of Forestry in Syracuse to create the Ranger School, first of its kind in the nation. The intensive one-year program trained men in practical field forestry and conservation. Gifts of land increased the acreage to 2,800. The current two-year curriculum prepares students to work as forest technicians, surveyors, or for transfer to a four-year college.

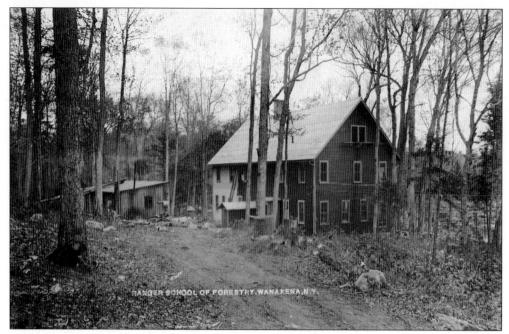

In the summer of 1912, the first students and faculty cleared the land, ran a telephone line, opened a passage to the main channel, and put up the first building, seen to the left. A shed with no plumbing, it served as office, kitchen, dining room, bunkhouse, and classroom. In 1913, the new building, to the right, housed offices and classrooms on the first floor, with second- and third-floor dorms. The shed was used as a woodshed and shop.

The first Ranger School class graduated in 1913 under director Philip T. Coolidge. This card, postmarked March 1915, shows the new dining hall west of the main building. A darkroom may have been part of the facilities, as the message notes, "This is a picture of the 2 buildings which Harold took and I printed. I send a card every day, but Mother says you get none and then 3 in one day, how does that happen?"

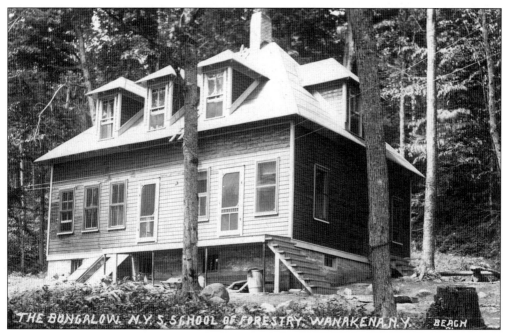

The dining hall at the Ranger School was constructed in 1914. It featured a mess hall and kitchen on the first floor, with cook's quarters on the second floor. Used until 1928, it was then renovated and still serves as the director's residence.

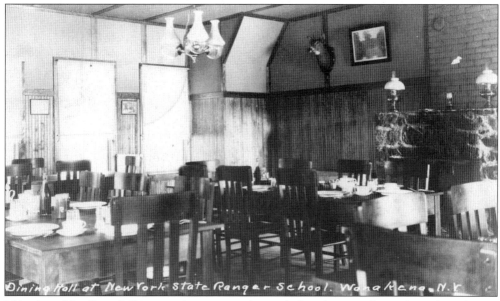

This view of the dining hall interior shows its simple, sturdy furnishings, well suited to a class of young outdoorsmen. Women were not admitted until 1974. The message on the card (sent in July 1918 from Wanakena to Detroit, Michigan) states, "This is where I lived for a year. It is hotter than blazes here and the mosquitoes are fierce." The writer omits the other notorious Adirondack pests—black flies, punkies, and deer flies, the "speckled-wing gentlemen."

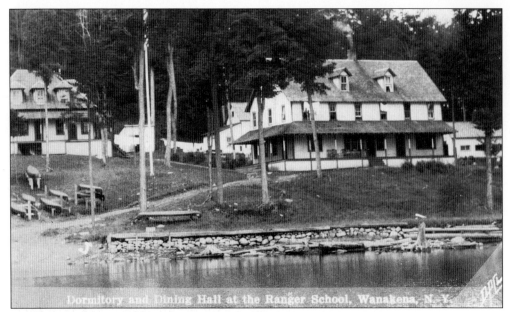

By the early 1920s, the main buildings at the Ranger School had been expanded, and new construction included a barn, machine shop, pump house, icehouse, sugarhouse, and boathouse. This card, sent to a professor at the Ohio Experimental Station in Wooster, bears this message: "Dear Sir—please send me bulletin No. 332 on Shade and Forest Insects. We are having a course in Entomology and it is very hard to get suitable books."

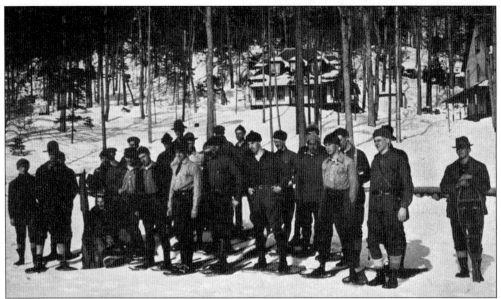

Most of the Ranger School's instructional activities were carried on outdoors, as seen in this October 1919 card. World War I veterans greatly increased enrollment, and tents on wood platforms were built to house them. This class is dressed for their snowshoe outing in layers of wool, heavier than modern synthetics, but just as warm, even when wet. Keeping feet dry in leather boots would have been difficult, long before silicon dressings and Gore-Tex liners.

Along with the establishment of the Ranger School came an interest in reforestation of the cut-over lands. The school established an experimental nursery in 1914 and began reforesting the land acquired from the Rich Lumber Company. This *c.* 1915 card is titled "5000 Young Spruce in Each Bed." After being planted from seed, the spruce spent their first year here.

During their second year, the young spruce were transplanted into these larger open beds. At four years, they were planted in the woods. Much of the Ranger School's 2,800 acres have been reforested with a variety of tree species by students and, in the 1930s, by the Civilian Conservation Corps.

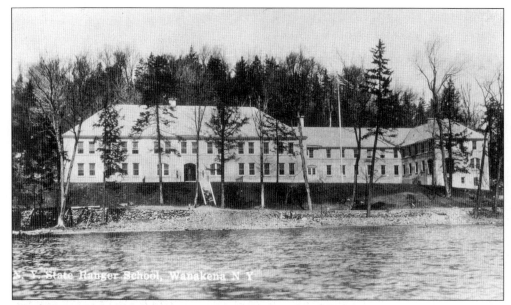

N. Y. State Ranger School, Wanakena N Y

In the 1920s, the state legislature appropriated $200,000 for the construction of new buildings at the Ranger School, under the term of the school's longest-serving director, James F. Dubuar (1921–1957). The old dorm and classroom building was replaced in 1928 by a larger main building, seen in the upper view. The center section housed the academic, dining, and recreational facilities, with an east side dormitory wing. This building was enlarged in 1961 by a new west wing, as seen in the lower card. A major capital improvement project is now under way, with renovations including an expansion of dormitory space and the addition of a lecture hall for distance learning. The school is expected to host workshops and serve as a conference center for the western Adirondacks.

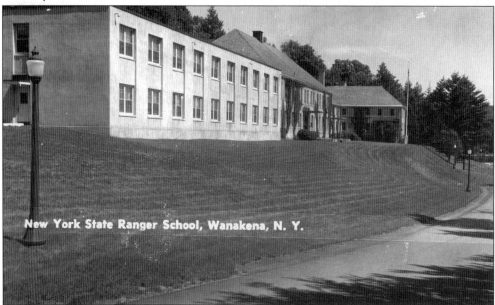

New York State Ranger School, Wanakena, N. Y.

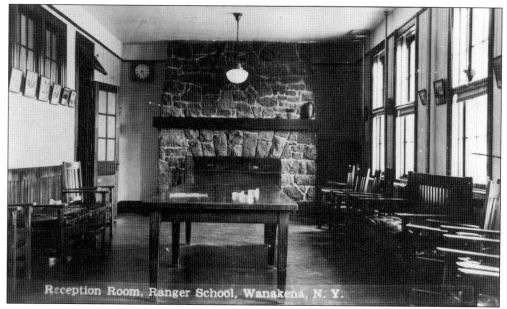

The 1928 new main building at the Ranger School added much needed administration and office space, including this reception room with its handsome stone fireplace.

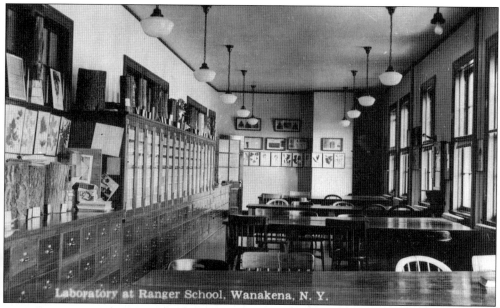

The laboratory in the new building reflected the school's new emphasis. Field forestry was still important, but equal time was to be devoted to classroom and laboratory work. Framed leaf mounts line the walls, and the cabinets are topped with logs and bark sections, samples from which the students could learn to identify a variety of trees.

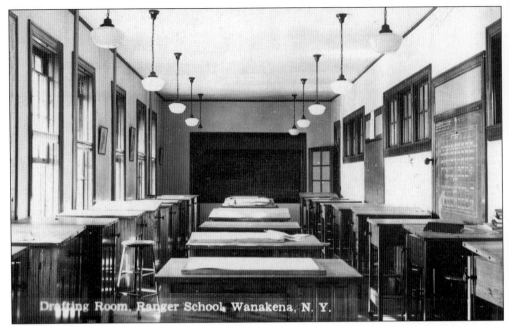

Drafting rooms were included to instruct students in technical drawing, mapping, and surveying. In 1937, one student wrote home, "We did topographic mapping today. Some rain, some shine. My partner and I got B's for the day's work. We make the map in the field as we proceed. Some fun." A large percentage of Ranger School graduates have traditionally found employment with surveying firms.

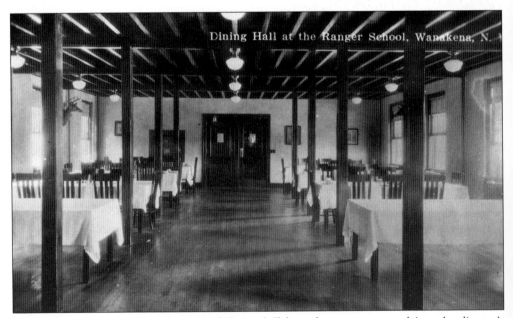

During the 1928 renovations, the original dining hall bungalow was converted into the director's residence. This large dining room was added to the new main building.

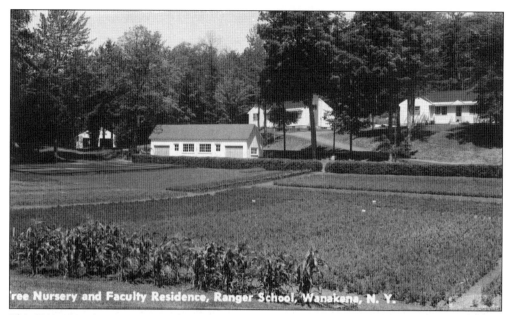

This 1940s view shows young trees being raised in open beds, in front of the seedling nursery shed, with faculty homes in the background. It was taken from the main entrance road, near where the North Shore Road from Wanakena village enters the campus. The view has changed only in that the surrounding trees are well grown up around the buildings.

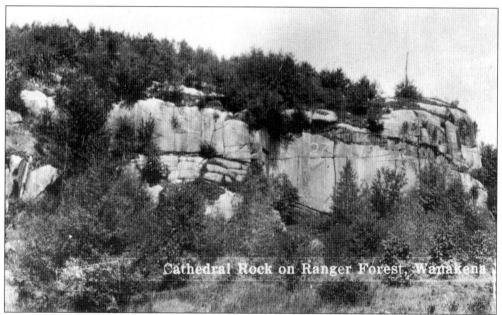

Cathedral Rock, on Ranger School property about a mile north of the Hotel Wanakena, towers over Eskar Pond. Many hotel guests hiked the short trail to this natural amphitheater. Over the last 30 years, however, the cliff has acquired an addition. Ranger School professor Kermit Remele, Class of 1943, dismantled and moved the fire tower from Tooley Pond Mountain, eight miles north. With students' help, it now stands reassembled on top of Cathedral Rock.

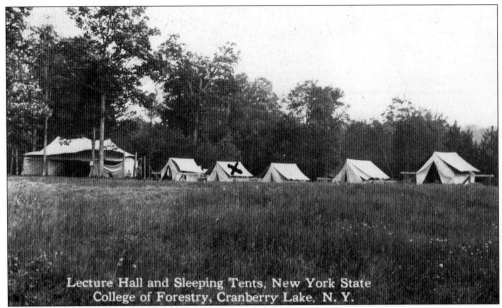

Lecture Hall and Sleeping Tents, New York State
College of Forestry, Cranberry Lake, N. Y.

In 1915, the New York State College of Forestry set up a summer camp at the mouth of Sucker Brook, on the southeast shore of Cranberry Lake. The 1,000-acre site, part of the Barber estate, had been used years before by a small sawmill operation. Faculty and students, arriving by barge, needed only to clear the area of brush. Both students and teachers were housed in army-surplus tents, with a larger tent serving as dining hall and classroom. In 1923, Charles Lathrop Pack purchased the property and deeded it to Syracuse University for use by the College of Forestry. The camp lasted 12 weeks, with students of all majors attending after their sophomore year. Both of these cards are postmarked 1921. The lower card, sent in September, notes, "See those tents? Well, I sleep in one of them and when I get up to wash I have to break the ice on the water."

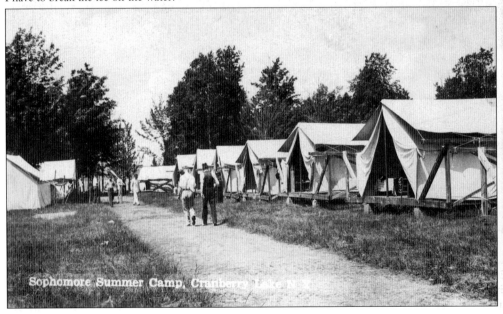

Sophomore Summer Camp, Cranberry Lake N. Y.

The first years of the forestry camp mixed camping, work, and field forestry. Students learned to fell trees and cut firewood. Work details included both maintenance and construction projects, with buildings, docks, and boathouses added by successive classes. By the time of this *c.* 1920 card, attendance was about 60 students. Conservationist Robert Marshall attended during the summer of 1922 and, with fellow students, cleared and marked trails in the area.

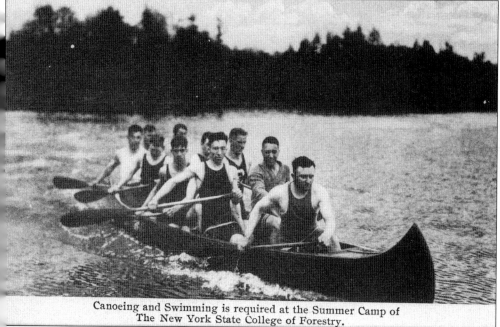

Canoeing and Swimming is required at the Summer Camp of
The New York State College of Forestry.

Each summer, the forestry camp and Ranger School took turns hosting a competition and field day. Events included wood chopping, sawing, tree felling, foot races, high jumping, swimming, canoe racing, and a tug-of-war. A barbecue followed, also enjoyed by tourists and residents. The Ranger School usually won the woodsmen's events, but this card shows forestry camp students paddling a 10-man war canoe, in earnest practice for the annual race.

Lest anyone think that the sophomore summer camp was all fun and games, the sender of this August 1933 card set the record straight: "This is not a recreational camp for boys. School is a snap in comparison with this, but it's a swell life just the same. At least I don't have any trouble eating or sleeping." No mention is made of what the students are studying so intently with their binoculars.

Administration Building, Sophomore Summer Camp

The earliest permanent construction at the summer camp was the administration building, seen in this 1932-postmarked card. It was flanked by tent platforms, still used to house students and faculty. The two women on the porch could be visiting relatives or tourists. The director at this time was Carlyn C. Delevan, serving from 1930 to 1957. Caretaker during most of the same period was Warren Guinup, a well-known early logging jobber.

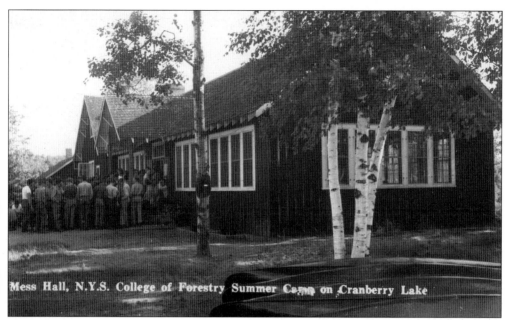

Mess Hall, N.Y.S. College of Forestry Summer Camp on Cranberry Lake

Students did not mind camping in army tents with insects and small animal visitors. However, attracting good cooks to such a primitive location was difficult. In 1935, a kitchen and dining hall was the second permanent building. Its large cellar served for storage. Students were called to meals by a locomotive bell, hung on a post by the kitchen door. These 1950s views show the mess hall after its post–World War II expansion. The dining hall was now capable of seating 200 people. The lower interior view shows its handsome hardwood floors, pine-board paneling, and many windows giving an open effect. The cooks were relieved of their more menial tasks by students, who peeled potatoes, washed dishes, toted garbage, and kept the kitchen and dining hall clean.

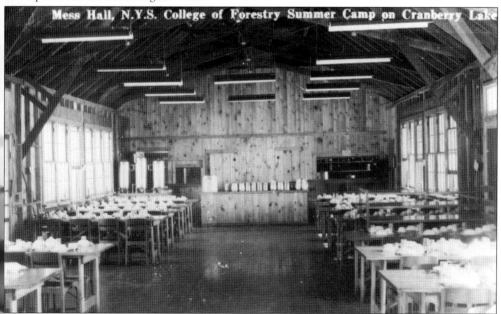

Mess Hall, N.Y.S. College of Forestry Summer Camp on Cranberry Lake

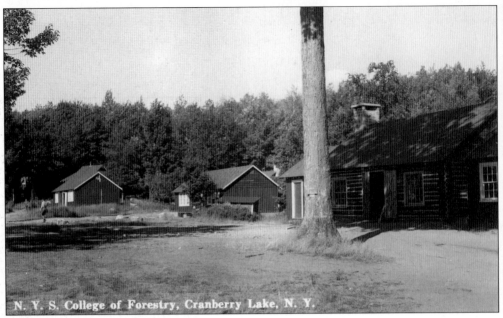

N. Y. S. College of Forestry, Cranberry Lake, N. Y.

After World War II, attendance at the forestry summer camp was boosted by veterans. In 1946, more than 150 students were enrolled. The camp was given a larger budget to fund new construction, including 12 sleeping cabins, 4 large classrooms, faculty housing, a powerhouse for the generators, recreation hall, year-round caretakers quarters, and a bathhouse. Construction continued into the 1950s. Some of the student housing cabins can be seen in this view.

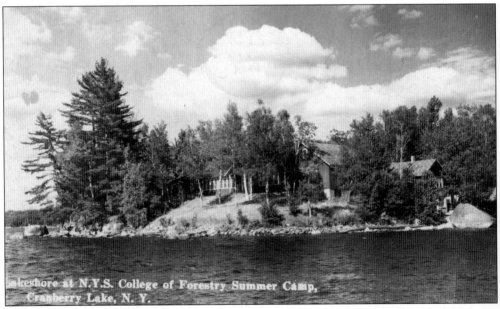

Lakeshore at N.Y.S. College of Forestry Summer Camp, Cranberry Lake, N. Y.

This 1951-postmarked card pictures the summer camp, on a point overlooking Sucker Brook Flow. To the far right is the Reuben Wood Rock, with its memorial inscription to the famous fly fisherman. The camp operated here until 1965 and was then moved to the Pack Forest near Warrensburg. The Cranberry site was renamed the Cranberry Lake Field Biology Station. It continues as a center for environmental and forest biology research.